Magic Lantern Genie Guides™

Nikon D3200
Quick Reference Card

Troubleshooting

Information Display does not appear in LCD monitor:
Shutter release button pressed down halfway; also, confirm [On] is selected for [Auto info display].

Display duration in LCD is too short:
Select longer duration for [Auto off timers].

Viewfinder display is dim and slow to react:
Display is affected by very high/low ambient temperature.

Camera start-up time is protracted:
Delete files/folders from installed memory card(s).

Shutter only fires once in Continuous Release modes:
Built-in flash raised; lower it.

Focus does not lock when shutter release button is pressed halfway when shooting via the viewfinder:
Use the AE-L/AF-L button to lock focus in AF-C focus mode, or AF-A mode when photographing a moving subject.

Cannot select AF point:
[Auto-area AF] selected for Auto-area mode when shooting via viewfinder, turn off monitor by pressing the shutter release button down halfway.

Cannot select AF-area mode:
Manual focus is selected.

Cannot change image size:
Image quality set to [NEF (RAW)] or [NEF (RAW) + JPEG].

Camera does not operate when remote control shutter release button is pressed:
Remote control battery exhausted, select a remote control release mode, flash is charging, time duration selected for [Remote on duration] has elapsed, high intensity light is interfering with IR signal from remote release.

Warning beep does not operate:
[Off] select for [Beep], quiet release mode selected, movie is being recorded, or manual or AF-C focus mode is selected.

Dark spots/marks or smearing appear in images:
Clean camera lens, clean lens filter, clean low-pass filter.

Date imprint does not work:
Image quality set to [NEF (RAW)] or [NEF (RAW) + JPEG].

Sound not recorded in movie mode:
[Off] selected for [Microphone].

Flicker or banding occurs during Live View or video recording:
Select appropriate option for [Flicker reduction] to match frequency of AC supply, flash or strobe-type light used during Live View/video recording.

Shutter speed range restricted:
Built-in/external flash in use; max sync speed is 1/200. A and P modes used with front curtain flash sync; speeds set between 1/60 – 1/250. If [On] is selected for [Manual movie settings], the range of shutter speed will be determined by the selected frame rate.

Camera unable to measure light in [Preset manual] white balance:
Reference target (e.g., white/grey card) too dark or too bright.

Reference image cannot be selected for [Preset manual] white balance:
Image not recorded by D3200 camera.

Appearance of image varies from picture to picture:
[Auto] selected for white balance, [Auto] selected for Picture Control, Exposure/white balance/ADL bracketing active.

Metering/Exposure settings cannot be altered:
Auto-exposure Lock in effect, Movie is being recorded.

NEF (RAW) image not available in Playback:
[Image quality] set to [NEF (RAW) + JPEG].

Not all pictures can be viewed:
[All] not selected for [Playback folder].

Photograph recorded in vertical (portrait) orientation displayed in horizontal orientation:
[Off] selected for [Rotate tall]. [Off] selected for [Auto image rotation]. Camera tilted up/down when image was recorded.

Selected photograph/video clip cannot be deleted:
Remove file protection; display file in Playback and press P button. SD memory card is locked.

Selected photograph cannot be edited in Retouch menu:
Image file not recorded by D3200 camera. Photo has already been edited using the same item in the Retouch menu.

DPOF print order cannot be altered:
Memory card is full. SD memory card is locked.

Photograph cannot be selected for printing:
NEF (RAW) cannot be printed via USB connection: Use [NEF (RAW) processing] to create a JPEG copy file, transfer file(s) to a computer and print using Nikon or third-party software.

Pictures cannot be displayed on TV / external monitor screen:
Choose correct video mode (NTSC / PAL). A/V or HDMI cable not corrected properly.

Camera does not respond to remote control for HDMI-CEC TV:
Select [On] for [HDMI] > [Device control].
Adjust settings for the HDMI-CEC device.

Image files not displayed by Nikon Capture NX2:
Update to Nikon Capture NX2 version 2.3.2 or later.

Image Dust Off feature in Nikon Capture NX2 does not work as expected:
Image sensor cleaning shifts position of dust on low-pass filter. Dust off reference file recorded before sensor-cleaning operation is performed; cannot be used with image file recorded after sensor-cleaning operation is performed. Dust off reference file recorded after sensor-cleaning operation is performed cannot be used with image file recorded before sensor-cleaning operation is performed.

Display of NEF (RAW) file on computer differs from display of same file on camera:
Computer operating system not compatible with camera or Nikon Transfer; copy data via a separate card reader.

Menu item not available (shown in grey):
Certain menu items are not available depending on current camera settings or when no memory card is installed.

Shutter release disabled:
Aperture ring not set to highest f/number, memory card is full, flash charging, focus not acquired. S-exposure mode used after F selected in M exposure mode, [Released locked] selected at [Slot empty release lock] and no memory card installed in camera.

Viewfinder appears out of focus:
Check and adjust viewfinder focus adjustment.

Camera does not acquire focus:
Switch to manual focus.

Consistent over- or underexposure:
Make sure no exposure compensation is set.

Flash pictures underexposed:
Reduce shooting range and/or use larger lens aperture/higher ISO.

Pictures are blurred:
Shutter speed too slow. Use faster speed and/or larger lens aperture, or increase ISO settings. Consider tripod, or other camera support.

Camera ceases to function properly:
Switch off, remove battery and replace it, switch on. If using the AC adapter, disconnect, reconnect, and switch on.

Nikon

Simon Stafford

MAGIC LANTERN GENIE GUIDES™

Nikon

D3200

Simon Stafford

ПIXIQ™

An Imprint of Sterling Publishing Co., Inc
Asheville

For more information
visit our website at www.pixiq.com

MAGIC LANTERN GENIE GUIDES™

Nikon

D3200

Simon Stafford

pıxıq™

An Imprint of Sterling Publishing Co., Inc
Asheville

For more information
visit our website at www.pixiq.com

Editor: Haley Steinhardt
Book Design: Michael Robertson
Cover Design: Thom Gaines, Electron Graphics

10 9 8 7 6 5 4 3 2 1

First Edition

Published by Pixiq
An Imprint of Sterling Publishing Co., Inc.
387 Park Avenue South, New York, N.Y. 10016

Distributed in Canada by Sterling Publishing,
c/o Canadian Manda Group, 165 Dufferin Street
Toronto, Ontario, Canada M6K 3H6

Distributed in the United Kingdom by GMC Distribution Services,
Castle Place, 166 High Street, Lewes, East Sussex, England BN7 1XU

Distributed in Australia by Capricorn Link (Australia) Pty Ltd.,
P.O. Box 704, Windsor, NSW 2756 Australia

If you have questions or comments about this book, please contact:
Lark Books
67 Broadway
Asheville, NC 28801
(828) 253-0467

Manufactured in Canada

ISBN 13: 978-1-4547-0802-5

For information about custom editions, special sales, premium and corporate purchases, please contact Sterling Special Sales Department at 800-805-5489 or specialsales@sterlingpub.com.

For information about desk and examination copies available to college and university professors, requests must be submitted to academic@larkbooks.com. Our complete policy can be found at www.larkcrafts.com.

To learn more about digital photography, go to www.pixiq.com.

Contents

Introducing the Nikon D3200

The intention of this Magic Lantern Genie Guide is to provide you with all the essential information and step-by-step instructions you need to start shooting great pictures with your D3200 as soon as possible. Its convenient size will enable you to carry the book in your camera bag, so it is always on hand as a ready reference in the field. Deliberately concise, it contains a comprehensive amount of information and a full set of instructions on how to operate the camera and configure it for different situations, use the expansive menu system effectively and efficiently, get the most out of the Nikon Creative Lighting System of flash units and accessories, and troubleshoot any problems you encounter when using the camera.

This Magic Lantern Genie Guide is available in both print and nook eBook form. (The nook book can be read on devices other than the nook by downloading the nook app.) If you want to do further reading about the D3200, be sure to check out the nook book; it includes bonus material on lenses and digital workflow.

CONVENTIONS USED IN THIS BOOK

Unless otherwise stated, when the terms "left" and "right" are used to describe the location of a camera control, it is assumed the camera is being held in horizontal shooting position. To ensure full compatibility, when camera functionality associated with lenses is discussed, it is assumed that either a D- or G-type Nikkor lens is attached to the camera. Likewise, it is assumed that a Nikon Speedlight compatible with the Nikon Creative Lighting System is used when I refer to any aspect of flash photography that involves an external flash unit or flash accessory. Note that lenses and flash units made by independent manufacturers may have different functionality; if you choose to use such products, be sure to verify that they will be compatible with your D3200 before purchasing the third-party equipment.

When I refer to Nikon software, note that the following versions, or later, are compatible with the D3200:

- Nikon View NX2 – version 2.3.1
- Nikon Capture NX2 – version 2.3.2

And remember, the more time you spend working with your camera, the more familiar and intuitive operating it will become, enabling you to translate your vision into gorgeous images!

Simon Stafford,
Wiltshire, England

Camera Controls

The external buttons and dials of the D3200 enable control of virtually all the major functions and features of the camera. Getting familiar with them will allow you to operate the camera more effectively and efficiently so that handling the camera becomes intuitive. This is the key to capturing great images, especially when you're shooting under pressure.

TOP OF THE CAMERA

Power Switch: Turn the camera on by rotating the power switch clockwise to align ON with the white index mark.

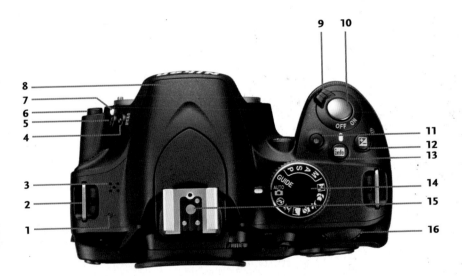

1. Focal plane mark
2. Camera strap eyelet
3. Speaker
4. Flash Pop-Up button / ⚡ Flash mode button / ⚡ Flash Compensation button
5. Fn Function button
6. Lens release button
7. Mounting mark
8. Built-in flash housing
9. Power ON/OFF switch
10. Shutter release button
11. Movie-Record button
12. ⚡ Exposure Compensation button / ○ Adjusting Aperture button / ⚡ Flash Compensation button
13. ⓘⁿᶠᵒ Info button
14. Mode dial
15. Hot shoe contact for accessory flash unit
16. Command dial

Shutter Release: Pressing the shutter release down halfway will activate the AF system, and if **[On]** is selected for **[Auto info Display]** in the Setup menu, the information display will be shown on the LCD monitor on the back of the camera. It will also show the approximate number of pictures that can be saved to the buffer memory at the current settings for image quality and size in the exposure count display in the viewfinder; the number of frames is prefixed by "r." If **[On]** is selected via **[Buttons]** > **[Shutter-release button AE-L]** in the Setup menu, exposure settings will be locked when the shutter release button is pressed down halfway.

NOTE: Press the shutter button down fully to release the shutter, ensuring you press it smoothly. Stabbing or jolting the shutter release is likely to cause a loss of image sharpness.

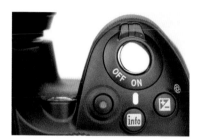

> The shutter release is in close proximity to a cluster of other controls, including the Movie-Record button, which is marked with a red dot.

Movie-Record Button: Press this button to start recording a video while the camera is operating in Live View. A recording indicator will appear in the top left corner of the LCD monitor, while a timer showing the maximum remaining duration of recording is displayed in the top right corner of the screen. Press the button again to stop recording.

Mode Dial: Rotate the MODE dial to select an exposure mode. Exposure mode determines how shutter speed and aperture are set when adjusting the exposure level. To maintain full availability of camera settings, select one of the following: P (Programmed Auto), S (Shutter-Priority), A (Aperture-Priority), or M (Manual).

To use the D3200 in a fully automated point-and-shoot way, select either ⚙ Auto, or ⚙ Auto Flash Off; it is important to understand that, in these modes, operation of many key camera controls is restricted. For example, TTL metering pattern, white balance, ISO sensitivity, exposure compensation, flash compensation, and Picture Controls cannot be adjusted by the user when shooting in one of the Auto modes. However, you can still refine your use of the camera during point-and-shoot style photography by selecting one of the dedicated Scene modes: 🎭 Portrait; 🏞 Landscape; 👶 Child; 🏃 Sports; 🌷 Close up; and 🌃 Night Portrait. In these scene modes, the camera will automatically optimize settings to match the subject/scene type being photographed. Finally, to assist photographers who would like some guidance with their photography as they go, the D3200 has a comprehensive Guide mode that displays hints and example pictures on the LCD monitor, together with direct access to camera functions pertaining to camera set up and viewing/deleting image files.

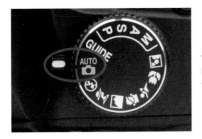

< To select a shooting mode, rotate the Mode dial so the required option is aligned with the white index mark. Here, it is set to the 🅰 Auto position.

Exposure Compensation Button: To use exposure compensation, press and hold the ⊠ button, then rotate the Command dial. The current value will be shown in the information display and viewfinder. At a value other than ±0.0, ⊠ is displayed in the viewfinder. To restore normal exposure, set compensation to ±0.0.

NOTE: Exposure compensation is not reset automatically when the camera is turned off. You must reset it manually using the ⊠ button and the Command dial.

Info Button: When shooting pictures via the optical viewfinder, use this button to switch the information display—shown on the LCD monitor—on or off.

FRONT OF THE CAMERA

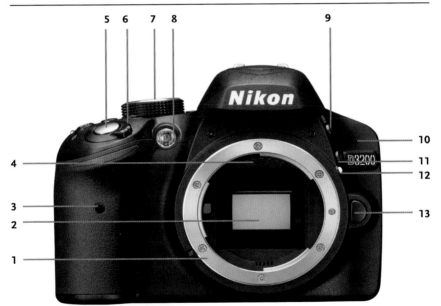

1. Lens mount
2. Mirror
3. Infrared receiver
4. CPU lens contacts
5. Shutter release button
6. Power ON / OFF
7. Mode dial
8. AF-Assist lamp / Self-Timer lamp / Red-Eye Reduction lamp
9. Flash Pop-Up button / 🔆 Flash mode button / 🔅⊠ Flash Compensation button
10. Microphone
11. Fn Function button
12. Mounting mark
13. Lens release button

Lens Release Button: To attach a lens, switch the camera off and align the mounting index mark on the lens with the mounting index mark (white dot) on the camera, then place the lens into the camera's lens mount bayonet. Rotate the lens counter-clockwise until the lens locks into place, taking care not to press the lens release. To remove the lens, switch the camera off, press and hold the lens release, then rotate the lens clockwise, waiting until the mounting index marks are aligned before withdrawing the lens from the camera.

› The Flash button is used to select the flash mode and, in combination with the ⊞ button, is used to set flash output compensation.

Flash Button: In the ᴬᵁᵀᴼ⬚ Auto and some Scene modes (⚋ Portrait, ⚋ Child, ⚘ Close up, and ⬚ Night Portrait), the built-in flash will activate automatically according to the prevailing light conditions. In the P, S, A, and M shooting modes, the built-in flash must be activated manually by pressing the ⚡ button. The built-in flash has a guide number (GN) of 12/39 (m/ft, ISO 100), though in manual flash mode the GN is 13/43 (m/ft, ISO 100). The flash provides illumination to cover the angle of view of a focal length of 16mm. Once the flash unit is fully charged, the flash-ready indicator ⚡ will be displayed in the viewfinder. (To read more about the built-in flash unit, and about using external flash units and accessories with the D3200, please refer to the chapter on xxThe Creative Lighting Systemxx.)

NOTE: The type of TTL flash exposure control is determined by the TTL metering pattern. To use i-TTL balanced fill-flash, select either Matrix or Center-Weighted metering; to use standard i-TTL flash, select Spot metering.

NOTE: To conserve camera battery power, lower the built-in flash when it is not being used; press it down until it locks into place.

› The Function button is located just above the lens release on the left side of the camera.

Function Button: The Fn button can be assigned a variety of roles. The available options are selected via **[Buttons]** > **[Assign Fn button]** in the Setup menu.

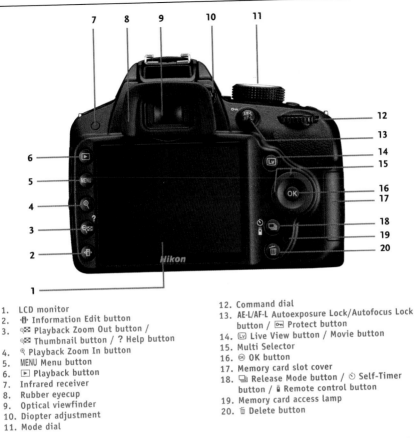

1. LCD monitor
2. ⊕ Information Edit button
3. ◙ Playback Zoom Out button / ◙ Thumbnail button / ? Help button
4. ◙ Playback Zoom In button
5. MENU Menu button
6. ▶ Playback button
7. Infrared receiver
8. Rubber eyecup
9. Optical viewfinder
10. Diopter adjustment
11. Mode dial

12. Command dial
13. AE-L/AF-L Autoexposure Lock/Autofocus Lock button / ⊡ Protect button
14. ⊡ Live View button / Movie button
15. Multi Selector
16. ◉ OK button
17. Memory card slot cover
18. ◙ Release Mode button / ⟳ Self-Timer button / ⬤ Remote control button
19. Memory card access lamp
20. 🗑 Delete button

Command Dial: This dial performs a number of roles when used in conjunction with other camera buttons. In M and S shooting modes, it is used to select shutter speed. It is also used to adjust aperture in M shooting mode by rotating it while the 🖫 button is pressed and held down. Details about how and when to use the Command dial are listed with each relevant topic or subsection.

‹ The AE-L/AF-L / ⊡ button has a dual functionality: to lock exposure and/or focus and to protect image files from accidental deletion.

AE/AF Lock Button: At the default setting for its operation, the **AE-L/AF-L** button will lock both exposure and focus. However, the button can also be assigned a range of other roles via **[Buttons] > [Assign AE-L/AF-L button]** in the Setup menu.

Protect Button: When reviewing photos in Playback, pressing the 🔒 button will protect photographs and video files from being deleted accidentally. Protected files are marked with the 🔒 icon when displayed on the monitor. To remove protection, display the protected photograph or video file on the monitor and press the 🔒 button.

Diopter Adjustment: Use this to adjust focus of the viewfinder display. Remove the lens cap and switch the camera on, point the camera at a light-toned, plain surface, then rotate the adjustment knob until the viewfinder display and focus screen markings appear sharp. Nikon offers a range of optional supplementary viewfinder eyepiece lenses if the degree of adjustment with this control is insufficient.

NOTE: Always cover the viewfinder eyepiece whenever the camera is used remotely (i.e., when your eye is not to the viewfinder) to prevent extraneous light from entering the camera and impairing the accuracy of the exposure metering system. The D3200 is supplied with the Nikon DK-5 accessory cover for this purpose. Slide the rubber eyecup upwards to remove it, and replace it with the DK-5.

Live View Button: Press the 🔲 button to activate Live View. The reflex mirror will be raised and the view through the lens will be displayed on the monitor.

Multi Selector: A multi-purpose control, the Multi Selector is used to navigate the menu system in conjunction with the ⊛ button, to select the AF point when shooting via the viewfinder, to position the AF point in Live View, and to select a thumbnail image in multi-image playback or menu displays.

OK Button: Pressing the ⊛ button will select the item/option highlighted currently in the information display or menu page shown on the monitor.

> The right thumb can conveniently reach all the controls clustered on the right side of the camera back, including the Release Mode button.

Release Mode Button: Press this button to display a list of the release mode options in the monitor. Select the required option to determine how and when the shutter will operate.

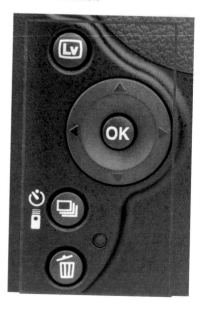

The release modes are as follows:

- ⑤ **Single Frame:** A single image is recorded each time the shutter release button is pressed. The camera will continue to record pictures until either its buffer memory is full or the memory card is full.
- ⑬ **Continuous:** Press and hold the shutter release button down, and the D3200 will continue to record images up to a maximum rate of 4 frames per second (fps).

NOTE: The quoted maximum frame rate is based on the camera being set to Continuous-servo AF (AF-C), M or S shooting mode, and a shutter speed of 1/250 second or faster. The buffer capacity, other autoexposure modes, and single-servo AF (AF-S) can, and often will, reduce the frame rate significantly, particularly in low-light conditions.

- ⊙ **Self-Timer:** The self-timer option is used to release the shutter after a predetermined delay. The duration of the delay and number of exposures is set via the **[Self-timer]** item in the Setup menu. Compose the picture, ensure proper focus, and then press the shutter release button. The AF-assist lamp will begin to blink (the audible warning will also beep if activated via **[Beep]** in the Setup menu) until approximately two seconds before the shutter is due to open, at which point the light stops blinking and remains on continuously (the frequency of the audible warning beep will increase) until the shutter is released.
- ⊙ 2s **Delayed remote:** The shutter is released two seconds after the shutter-release button of the optional Nikon ML-L3 infrared (IR) remote control is pressed.
- ⓘ **Quick-response remote:** The shutter is released as soon as the shutter-release button on the optional Nikon ML-L3 remote control is pressed.

In either of the two remote control modes, confirm focus by pressing the shutter release halfway; note that even if the shutter release is pressed down fully, no exposure will be made. Point the transmitter window on the curved edge of the ML-L3 toward either of the two IR receivers on the D3200 (one is located on the front of the camera below the right-hand finger grip, and the other on the rear of the camera to the left of the viewfinder eyepiece), and press the shutter-release button of the ML-L3. In Delayed remote mode, the self-timer lamp will light for approximately two seconds before the shutter is released; in Quick-response remote mode, it will flash after the shutter has been released.

NOTE: At the default setting for the **[Remote on duration]** item in the Setup menu, the camera will default automatically back to the previously selected release mode (single-frame, continuous, or quiet shutter-release) if no camera operations are performed for approximately 60 seconds after selecting either to the two remote control modes. Use this menu item to select a longer duration for the camera to wait to receive a signal from the ML-L3 remote release.

NOTE: If you do not have your eye to the viewfinder when using the self-timer feature (or either of the two remote control release modes) in any shooting mode other than M mode, it is essential to cover the viewfinder eyepiece to block extraneous light from entering the camera and influencing the TTL metering system. Otherwise, exposure accuracy may be compromised. You can use the supplied DK-5 accessory viewfinder cover. Or, alternatively, I keep a small piece of black felt material that I drape over the viewfinder eyepiece, which I find far quicker and more convenient to use.

NOTE: The ML-L3 has a maximum effective range of approximately 16 feet (5 m), although this is likely to be reduced in very bright sunlight due to the high level of naturally occurring IR light.

NOTE: The camera's timer may not start or the shutter may not be released if focus is not acquired. To cancel the self-timer or remote control operation, switch the camera off.

- **Q Quiet shutter release:** This release mode separates the action of raising the reflex mirror and opening the shutter from the subsequent lowering of the mirror and recycling of the shutter mechanism, which makes the camera noticeably quieter compared with firing the shutter in single-frame mode. Pressing the shutter release down fully will fire the shutter. Then, keep it pressed to prevent the reflex mirror from lowering, which allows you to determine when this will occur by deciding when to lift your finger off the shutter release button. This mode is ideal for shooting in any environment where you need to be discreet.

Delete Button: Press the 🗑 button to delete a photograph displayed in full-frame playback or highlighted in thumbnail playback. The 🗑 button is also used to delete movie files. Pictures that are protected (⌐⊶) cannot be deleted.

Playback Button: Press the ▶ button to review a photograph full frame on the monitor. The most recent picture will be displayed. Use the Multi Selector to scroll through other pictures and to display additional information about the currently displayed picture.

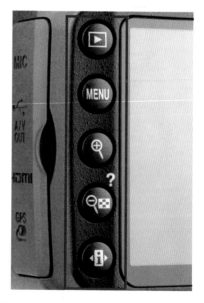

> The buttons arranged along the left edge of the monitor are principally used for reviewing images and accessing the menu system.

Menu Button: Press the MENU button to enter the camera's menu system. The name of the menu displayed currently is shown at the top of the monitor, while its icon, shown in the column at the left of the screen, will be highlighted. If **?** is displayed in the lower left corner of the screen, a description of the menu item highlighted currently can be viewed by pressing the ⊖▦ button.

Playback Zoom In Button: When a photograph is displayed full frame in the monitor, pressing the ⚲ button will magnify it up to a maximum of approximately 38x (large size file). Use the Multi Selector to shift to other areas of the picture not displayed on the monitor. A navigation window is displayed when the picture is magnified, with the area shown currently on the monitor framed with a yellow border.

Playback Zoom Out Button / Thumbnail Button: When a photograph is displayed full frame in the monitor, pressing the ⚲ button will display multiple photographs; the number of pictures increases from 4, to 9, to 72 with each successive press of the button. Use the Multi Selector to highlight a specific picture (it will be surrounded by a yellow frame line) and press the ⓞⓚ button to view the picture at full frame magnification.

Information Display Button: Press this button to show the information display on the monitor; press it again to show the current position of the highlight cursor. Use the Multi Selector to shift the position of the cursor to select an alternative item, and press the ⓞⓚ button to display the options available for the item.

LCD INFORMATION DISPLAY

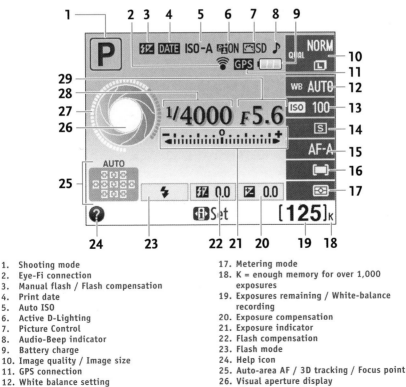

1. Shooting mode
2. Eye-Fi connection
3. Manual flash / Flash compensation
4. Print date
5. Auto ISO
6. Active D-Lighting
7. Picture Control
8. Audio-Beep indicator
9. Battery charge
10. Image quality / Image size
11. GPS connection
12. White balance setting
13. ISO setting
14. Release mode
15. Focus mode
16. AF-area mode
17. Metering mode
18. K = enough memory for over 1,000 exposures
19. Exposures remaining / White-balance recording
20. Exposure compensation
21. Exposure indicator
22. Flash compensation
23. Flash mode
24. Help icon
25. Auto-area AF / 3D tracking / Focus point
26. Visual aperture display
27. Shutter speed display
28. Shutter speed setting
29. Aperture setting

THE VIEWFINDER

The D3200 has a fixed-optical pentaprism eye-level viewfinder that shows approximately 95% (vertical and horizontal) of the full-frame coverage. The focusing screen is a type B BriteView clear matte Mark VII, and the viewfinder provides a magnification of approximately 0.8x. The viewfinder display includes essential information about exposure and focus, including shutter speed, lens aperture, exposure compensation factor, ISO value, focus confirmation, battery status indicator, and flash-ready signal, and more.

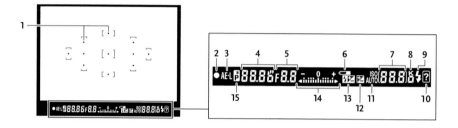

1. Focus points
2. In-focus indicator
3. Autoexposure Lock (AE-L) indicator
4. Shutter speed setting
5. Aperture setting
6. Battery charge indicator
7. Exposures remaining/White balance/ Exposure compensation value
8. K = enough memory for over 1,000 exposures

9. Flash ready indicator
10. Warning indicator
11. Auto ISO indicator
12. Exposure compensation indicator
13. Flash compensation indicator
14. Exposure indicator/Exposure compensation/ Rangefinder
15. Flexible program indicator

Shooting with Your D3200

EXPOSURE MODES

Regardless of whether you are content to let the D3200 make decisions about exposure settings or you want to adjust them for yourself, it is essential to understand how the camera sees, evaluates, and processes light.

AUTO AND SCENE MODES

The 📷 Auto mode, ⚡ Auto (flash off) mode, and six dedicated Scene modes represent the most automated level of control available on the D3200. The camera manages many key controls and features in an attempt to select a combination of settings that will be appropriate for the subject type or scene being photographed. It does this by using information from the through-the-lens (TTL) metering system, which assesses the overall level of illumination, contrast, and color quality of the prevailing light, together with information from the autofocus system used to estimate the location of the subject in the frame area and its distance from the camera, plus additional information from the camera's sensor to control automated white balance. This leaves you with limited ability to intervene and override settings, but this is unlikely to be of any significant concern to the novice photographer who is content to let the D3200 make decisions on their behalf. For the more experienced user, shooting in Aperture Priority, Shutter Priority, or Manual exposure mode will offer a far greater degree of camera control.

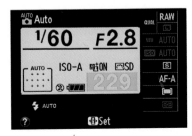

‹ The Information Display for the 📷 mode; notice how several items such as image size, white balance, ISO, and metering are grayed out, as they cannot be altered from default settings in the automated point-and-shoot exposure modes.

HINT: Less experienced users may find the **[Graphic]** option (selected under the **[Info display format]** item in the Setup menu) helpful in understanding the relationship between shutter speed and aperture, as it is shown by way of a diagram in the Information Display.

SETTINGS IN AUTO & SCENE MODES

When using the ᴬᵁᵀᴼ and Scene modes, the level of user control is restricted, but the following controls can be adjusted from their default settings in most cases: image quality, image size (JPEG only), ISO, AF mode, AF-Area mode, flash mode, and D-Movie settings. If you alter any default setting, it is only retained while the camera remains in the current shooting mode. If you turn the **MODE** dial to another shooting mode, the default setting is restored.

In the ᴬᵁᵀᴼ and Scene modes, the following cannot be adjusted from the default setting:

- o Metering
- o ISO sensitivity (ᴬᵁᵀᴼ and ⚡ only)
- o Exposure Compensation
- o Active D-Lighting
- o White Balance
- o Picture Controls (Contrast and Sharpening are applied automatically)
- o AF-Area mode (ᴬᵁᵀᴼ and ⚡ only – in Live View/Movie)
- o Flash mode (TTL flash exposure control is always used)
- o Flash Compensation
- o AE-L/AF-L button (ᴬᵁᵀᴼ and ⚡ only)

NOTE: If an item is grayed out in the Information Display when using the ᴬᵁᵀᴼ, ⚡ and Scene modes, it is not available to be adjusted.

ᴬᵁᵀᴼ **Auto:** The ᴬᵁᵀᴼ mode is designed as a universal point-and-shoot mode and is most effective for general-purpose snapshot photography.

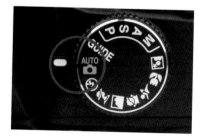

> The green icon indicates a "go" for more inexperienced users of DSLRs.

⚡ **Auto (Flash Off):** This mode is essentially the same as the ᴬᵁᵀᴼ mode, with the exception that the built-in flash is turned off and will not operate, regardless of the level of ambient illumination, even if it is very low. It is useful in situations where the use of flash is undesirable, like in naturally low-light conditions where flash would spoil the atmosphere of the scene, or where the use of flash is prohibited. Although

the built-in flash is disabled, the AF-Assist illuminator lamp will still function in poor lighting conditions.

> **HINT:** Since the camera can set slow shutter speeds in this mode, always check the viewfinder information to ensure that the selected shutter speed will allow the camera to be held without risk of camera shake affecting the picture. At slow shutter speeds, consider using a camera support such as a tripod.

Portrait: The mode is designed to select a wide aperture (low f/number) in order to produce a picture with a shallow depth of field. Generally, this renders the background out-of-focus, which helps to isolate the subject, although the effect is also dependent on the distance between the subject and the background and the focal length of the lens. This mode is most effective with focal lengths of 70mm or longer, and when the subject is relatively far away from the background.

Landscape: The mode is designed to select a small aperture (high f/number) in order to produce a picture with an extended depth of field. Generally, this renders everything from the foreground to the horizon in focus, although that will depend to some degree how close the lens is to the nearest point in the scene.

> **HINT:** When using a short focal length (less than 35mm), try to include an element of interest in the foreground and middle distance, to help produce a balanced composition and a way of leading the viewer's eye into the picture.

Child: The parameters are similar to the mode, except the Picture Control is Standard to give a more vibrant rendition of color.

> **HINT:** One of the simplest ways to improve pictures of children is to lower the camera to their eye level.

Sports: The mode is designed to select a wide aperture in order to maintain the highest possible shutter speed to "freeze" motion in fast-paced action. It also has a beneficial side effect: The wide aperture produces a picture with a shallow depth of field that helps to isolate the subject from the background. This mode is most effective with long-focal-length lenses (100mm or longer) and when there are no obstructions between the camera and the subject that may cause autofocus to focus on something other than the subject.

> **HINT:** There is always a slight delay between pressing the shutter release button and the shutter opening; therefore, it is important to anticipate the peak moment of the action and press the shutter just before it occurs. The decisive moment will be missed if you wait to see it in the viewfinder before pressing the shutter release.

Close-Up: The mode is for taking pictures at close shooting distances of subjects such as flowers, insects, and other small objects. It is designed to select

a small aperture (high f/number) in order to produce a picture with an extended depth-of-field. Generally, depth of field is limited when working at very short focus distances, even when using small apertures, so this mode tries to render as much of the subject in focus as possible. The final effect will also be dependent on how close the camera is to the subject and the focal length of the lens used.

Night Portrait: The ☒ mode is designed to capture properly exposed pictures of people against a background that is lit dimly. It is useful when you want to include background detail such as a cityscape at twilight and is most effective when the background is in low light, as opposed to near dark or totally dark conditions. The built-in Speedlight will activate automatically in low light; alternatively, an external Speedlight such as the SB-400, or SB-700 can be used to supplement the ambient light.

AUTO, FLASH OFF, SCENE MODE DEFAULT SETTINGS

MODE/CONTROL	WHITE BALANCE	PICTURE CONTROL	FLASH SYNC MODE	ACTIVE D-LIGHTING	AF-AREA MODE
AUTO	Auto	Standard	Auto	Auto	Auto-Area
AUTO (Flash off)	Auto	Standard	Flash off	Auto	Auto-Area
Portrait	Auto	Portrait	Auto	Auto	Auto-Area
Landscape	Auto	Landscape	Flash off	Auto	Auto-Area
Child	Auto	Standard	Auto	Auto	Auto-Area
Sports	Auto	Standard	Flash off	Auto	Dynamic-Area
Close up	Auto	Standard	Auto	Auto	Single-Point
Night Portrait	Auto	Portrait	Auto Slow	Auto	Auto-Area

GUIDE MODE

In line with the design ethos of the D3200 to provide simple, intuitive operation, even for the complete novice photographer, Nikon is always improving on the GUIDE mode.

GUIDE mode is probably best described as an alternative way of using the ⚙ Auto, ⚡ Auto (Flash Off), Scene, Shutter Priority, Aperture Priority, and Programmed Auto exposure modes. The difference is that in GUIDE mode you are supported by a highly descriptive interface, which is peppered with graphics and example images to assist you in learning how to achieve successful pictures in specific shooting situations. The GUIDE mode interface also embraces a number of the camera controls that can be accessed from the normal Information Display, and items from the camera's menu system, which makes it more flexible than shooting in the ⚙

Auto, ⚡ Auto (Flash Off), and Scene modes. Camera settings made within the GUIDE mode are completely autonomous from settings made in the Information Display and menu system when using any other exposure mode.

Turn the MODE dial to GUIDE and press the MENU button; the GUIDE mode is structured around three main strands: [Shoot], [View/delete], and [Set up], which are displayed as soon as the top level GUIDE mode display opens. Within each strand, you are led through a sequence of pages displayed on the monitor that set out clearly what, how, and why settings are selected. Some examples of the GUIDE mode are on the pages that follow.

Main Menus: From this screen, choose the function you want to access.

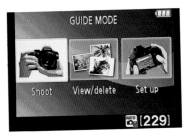

‹ The three strands of GUIDE mode: [Shoot], [View/delete], and [Set up].

Shoot (Easy Operation): The [Easy operation] options allow you to select a specific subject / scene type. For example, [Sleeping faces] uses the settings for the Child scene mode, but modified, so the flash does not operate and the release mode is set to [Quiet shutter release] to reduce the risk of disturbing the subject.

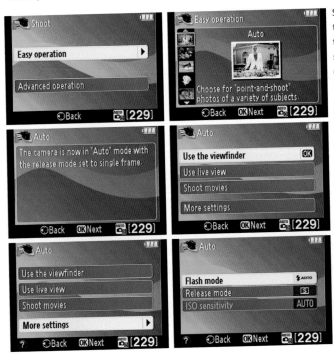

Select [Easy operation] from the [Shoot] strand. You then have the choice to select from a number of different specific camera operation / subject / scene types. Here, [Auto] has been selected and a suggestion when to choose the option is shown. The next page provides additional information about the selected option, the following page provides access to three shooting options: [Use the viewfinder], [Use live view], [Shoot movies]. The [More settings] option enables adjustment of a number of different options (the range of available options will depend on the selected shooting mode).

To use Easy Operation, start by highlighting [Shoot] and press ⊛; highlight [Easy operation] and press ▶. Next, press ▼ or ▲ to highlight the required mode, and press ⊛ to select it. Press ▶ to display a brief description of the selected option. Press ▶ to open the next page and view the three shooting options: [Use the viewfinder], [Use live view], and [Shoot movies]. The [More settings] item enables adjustment of a number of options (the range of which will depend on the selected shooting mode). If you accessed the [More settings] page, highlight the required item(s), make the necessary adjustment(s), and then press ◀ to return to the shooting method options page. To begin shooting, highlight the required option and press ⊛.

NOTE: Depending on the selected shooting mode, the option to adjust certain settings within [More settings] may not be available (in this case, the item will grayed out). For example, the Flash Sync mode cannot be changed in [Distant subjects] and [Moving subjects].

Shoot (Advanced Operation): The options available within [Advanced operation] are for refining control to achieve specific pictorial effects, such as [Soften backgrounds] to blur the background by using a large aperture setting, or [Freeze motion (people)] that sets the camera to S (Shutter Priority) mode, so a specific shutter speed can be selected.

The following sequence of screen shots shows the path through the [Advanced operation] > [Soften backgrounds] option to select the aperture value, showing each page in chronological order:

At the bottom right is the [More settings] page within [Advanced operation] > [Soften backgrounds].

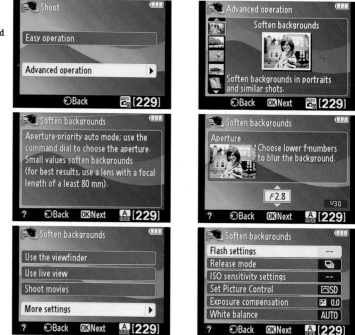

At this point, you can choose to begin shooting, using either the [Use the viewfinder], [Use live view], or [Shoot movies] option, or you may adjust other settings by selecting [More settings].

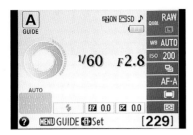

< You will always know when you are in GUIDE mode, as the word GUIDE is displayed beneath the exposure mode icon in the top left corner of the monitor and in the menu bar at the bottom of the screen.

Regardless of the option selected within [Easy operation] or [Advanced operation], once the camera is in its selected shooting mode ([Use the viewfinder], [Use live view], or [Shoot movies]), any available settings can be adjusted by pressing the ⬛ button to open the ID (Information Display). Move the highlight cursor to the required option and press the ⊛ button. Select the required setting by highlighting it and press the ⊛ button. To return to the ID in viewfinder shooting, Live View, or D-Movie mode respectively, press the ⬛ button again.

View/Delete: The options within this menu determine the following: viewing image files either singularly or in multiples of four; selection of pictures / video taken on a specific date; display of pictures / video as a slide show; and deletion of pictures / video, either as multiple files, by date, or all image files.

The items available within [View/delete] in the GUIDE mode.

Set Up: This menu contains a range of selected items from the main Playback, Shooting, and Setup menus. Note that changes to [Output settings], [Playback folder], [Playback display options], [DPOF print order], [Clock and language], [Eye-fi upload], and [Slot empty release lock] affect all shooting modes, while changes made to other items in this menu apply only in GUIDE mode.

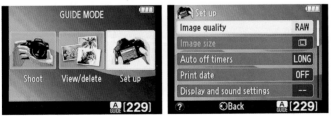

These are the items available within [Set up] in the GUIDE mode (first page only).

P, A, S, AND M EXPOSURE MODES

These exposure modes, sometimes called shooting modes, offer a variable level of control over the shutter speed and aperture, while enabling full control over other settings on the D3200; they do not impose any of the restrictions that apply when using the Auto mode, Auto (Flash Off) mode, and six dedicated Scene modes. To select one, rotate the MODE dial until the required mode is aligned with the white index mark.

NOTE: When a CPU-type lens with an aperture ring is attached to the camera, ensure the aperture is locked at its minimum value (highest f/number).

P **Programmed Auto:** In this mode, the camera adjusts both the shutter speed and the lens aperture automatically to produce a properly exposed image, as determined by the selected TTL metering mode. To override the combination of shutter speed and aperture chosen by the camera, rotate the Command dial while metering is activated; this is known as Flexible Program mode. P* appears in the Information Display and viewfinder when Flexible Program mode is in use. The two values change in tandem, so the overall exposure level will remain the same (i.e., increasing the shutter speed decreases the aperture). To cancel Flexible Program, rotate the Command dial until the asterisk next to the P is no longer displayed, change exposure mode, or turn the camera off.

HINT: In Program mode, control of exposure is relinquished to the camera, just as it is in the 🅰️ and the Scene modes, making the D3200 no more than a point-and-shoot. To make your own decisions about shutter speed and aperture for creative photography, avoid this mode.

A **Aperture-Priority Auto:** In this mode, you select the aperture value and the D3200 chooses a shutter speed to produce an appropriate exposure, as determined by the selected metering mode. The aperture is controlled by the Command dial and is changed in steps of 0.3 EV. The shutter speed the camera selects will also change in steps of 0.3 EV.

> To set the exposure mode, rotate the MODE dial. Here, it is set to A (Aperture-Priority).

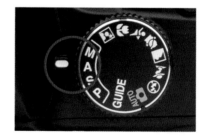

S **Shutter-Priority Auto:** In this mode, you can select a shutter speed between 30 seconds and 1/4000 second and the camera will choose an aperture value to produce an appropriate exposure, as determined by the selected metering mode. The shutter speed is adjusted via the Command dial in steps of 0.3 EV. The aperture value the D3200 selects will also change in steps of 0.3 EV.

^ The amount of white water varied significantly in this scene, so to ensure consistent exposure between consecutive frames the camera was set to Manual exposure mode.

NOTE: In P, A, and S modes, if the limits of the exposure metering system are exceeded, the shutter speed value (in P and A modes), and aperture value (in P and S modes) will flash as a warning.

M **Manual:** Manual exposure mode provides complete control over the exposure. Select the shutter speed by turning the Command dial and the aperture by pressing and holding the ☒ button while turning the Command dial. You will see an analog exposure scale in the Information Display and the viewfinder. If the metering system determines that the current combination of shutter speed and aperture will produce a proper exposure, a single bar mark appears below the mid-point of the scale. If the current settings would produce an underexposed result, the degree of underexposure is indicated by the number of bar marks to the left (negative) side of the mid-point. Conversely, if the settings would produce an overexposed result, the degree of overexposure is indicated by the number of bar marks to the right (positive) side of the mid-point.

LONG TIME EXPOSURES (M MODE ONLY)
To shoot at exposure durations longer than 30 seconds, select M exposure mode and set the shutter speed to 𝚋𝚞𝙻𝚋. Mount the camera on a tripod or other form of stable support, focus the lens, then press and hold the shutter release button down. To end the exposure, release the button.

Alternatively, the shutter can be released using the optional ML-L3 remote release. In this case, start by setting the shutter speed to bulb, then set the camera to either its Delayed Remote or Quick-Response Remote mode; the shutter speed in the Information Display will be displayed as Time, while (- -) is shown in the viewfinder. To start the exposure, press the release button on the ML-L3. To end the exposure, press it again. Note the exposure will end automatically after 30 minutes.

AE-L AUTOEXPOSURE LOCK

Use this feature to lock exposure settings in P, S, and A modes with Center-Weighted or Spot metering. With AE-L activated, you can recompose your picture without affecting the exposure level. Position the area of the metering pattern and an AF point (if using autofocus) over the subject, press the shutter release button down halfway to acquire focus and an exposure reading, then press and hold the AE-L/AF-L button to lock exposure and focus (assuming [AE/AF lock] is selected for [Buttons] > [Assign AE/AF button] in the Setup menu). While the lock is active, AE-L will appear in the viewfinder display. It is possible to alter exposure settings in P mode (shutter speed or aperture), A mode (aperture), and S mode (shutter speed) without altering the metered exposure level.

HINT: The shutter release button can perform the Autoexposure Lock function, if you select [On] at [Buttons] > [Shutter-release button AE-L] in the Setup menu. In this case, the exposure will lock when the shutter release button is held down halfway.

HINT: Use of Autoexposure Lock is not recommend with Matrix metering, as it may produce inconsistent results.

EXPOSURE COMPENSATION

This feature is used to alter the exposure level from the value calculated by the camera. In the P, A, and S exposure modes, it is the only way to override the TTL metering system, and it produces the most consistent results with either Center-Weighted or Spot metering. The metering system works on a broad assumption that every scene reflects approximately the same proportion of light, regardless of light intensity, where the degree of reflectivity is equivalent to a midtone. If the scene / subject reflects more light (such as a landscape under a blanket of fresh snow) or less light (such as an animal with a dark coat), the exposure level suggested by the camera is likely to be inaccurate. Consequently, it will be necessary to apply exposure compensation.

To set exposure compensation, hold down the ☒ Exposure Compensation button and rotate the Command dial until the required value is shown in the viewfinder and Information Display. Alternatively, press the ☷ button to open the Information Display, and press it again to show the highlighted cursor; highlight exposure

compensation and press ⊛. Highlight the required value and press ⊛ to select it. Press the shutter release button down halfway to return to the shooting mode.

The ☒ icon is shown in the viewfinder and Information Display when exposure compensation has been applied. exposure compensation remains locked at the selected value until you change it; it will not reset when you turn the camera off. To remove exposure compensation, you must manually reset its value to ±0.0.

NOTE: In M exposure mode, exposure compensation only affects the exposure scale display (i.e., it serves to illustrate whether the camera interprets the potential values as a "correct" exposure, or under- or overexposure). The actual shutter speed and aperture values do not change unless you alter them.

ISO SENSITIVITY

The D3200's normal range of ISO sensitivity settings is from ISO 100 to ISO 6400, adjustable in steps of 1.0 EV. The ISO range can be expanded to approximately 1.0 EV above ISO 6400 (ISO 12,800 equivalent), where the ISO value is displayed as Hi 1.

The sensor delivers its optimal performance at the base value of the normal sensitivity range, ISO 100. Therefore, I recommend you shoot at the lowest appropriate ISO setting (within the normal range) for the subject/shooting conditions.

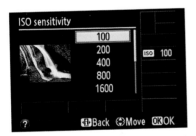

‹ The ISO value can be set from the Information Display.

To adjust the ISO sensitivity manually, press the ⊞ button to open the Information Display, and press it again to show the highlighted cursor. Highlight ISO and press ⊛. Highlight the required ISO value and press ⊛ to select it. Press the shutter release button down halfway to return to the shooting mode. Alternatively, ISO can be adjusted via the [ISO sensitivity settings] item in the Shooting menu.

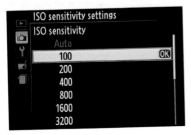

‹ The ISO value can also be set from the menu system.

ISO NOISE

As the ISO sensitivity value is increased above ISO 100, images will show increasing amounts of electronic noise, characterized by a grainy appearance and often associated with blotchy color patterns and reduced color saturation and contrast. The [Noise reduction] item in the Shooting menu can be used to help reduce the effects of noise at high ISO settings. It can be quite effective, although it will result in some loss of definition in very fine detail. Unless you have good reason to try and deal with ISO noise in camera, it is usually preferable to use either the noise reduction feature of an NEF (RAW) file converter, or a dedicated noise reduction application, such as Noise Ninja (www.picturecode.com) or Neat Image (www.neatimage.com).

NOTE: The D3200 exhibits extremely minimal noise characteristics up to ISO 800. Above this level, particularly with long exposures, some form of noise reduction is likely to be necessary.

AUTO ISO SENSITIVITY CONTROL

The D3200 can adjust ISO sensitivity automatically according to lighting conditions. This feature is set via the [Auto ISO sensitivity control] option under the [ISO sensitivity settings] item in the Shooting menu. It is important to understand how this feature works: In P and A exposure modes, ISO sensitivity will not be altered unless underexposure would occur at the value specified for the [Minimum shutter speed] option. The range for [Minimum shutter speed] extends from 1 second to 1/2000 second. However, if the camera cannot achieve a proper exposure at the value specified for the [Maximum sensitivity] option, which covers the range from ISO 200 to Hi 1 (ISO 12,800), the D3200 will then begin to select slower shutter speeds. If [Auto] is selected for [Minimum shutter speed], the camera will base its choice of shutter speed on the focal length of the lens.

> This is the [Auto ISO sensitivity control] display in the Shooting menu.

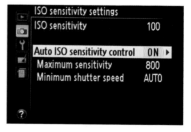

In S exposure mode, ISO sensitivity is shifted when the maximum aperture available on the lens will not achieve a proper exposure. [Auto ISO sensitivity control] is probably most useful with this exposure mode, as it will raise the ISO value to maintain the pre-selected shutter speed, which is usually critical to the success of the picture. In M exposure mode, the sensitivity is shifted if the selected combination of shutter speed and aperture cannot attain a correct exposure. When [Auto ISO sensitivity

control] is active, ISO-AUTO is displayed in the viewfinder and ISO-A is shown in the Information Display. If the camera alters the ISO sensitivity from the selected value, ISO-AUTO / ISO-A will blink as a warning.

TTL METERING MODES

The D3200 has three metering pattern options: Matrix, Center-Weighted, and Spot. To select the metering pattern, press the ⊞ button to open the Information Display, and press it again to show the highlighted cursor. Highlight Metering and press ⓞ. Highlight the required option and press ⓞ to select it. Press the shutter release button down halfway to return to the shooting mode. Alternatively, the metering pattern can be selected via the [Metering] item in the Shooting menu.

⊡ MATRIX METERING

This metering pattern covers virtually the entire frame area, with the 420 pixels / segments on the RGB metering sensor (located in the viewfinder head of the camera) acting as a sampling point. In front of the sensor is a diffraction grating that separates the light into its component colors to improve the efficiency and accuracy with which it assesses the nature and color of the light, which is a core function of the Scene Recognition System that assesses the distribution of color within the frame to improve metering and autofocus accuracy. Matrix metering uses five principle factors when calculating an exposure value:

- o The overall level of illumination in the scene.
- o The ratio of brightness between the 420 pixels (brightness pattern).
- o Distribution of color within the scene.
- o The focused distance, provided by the lens (D- or G-type only).
- o The location of the active AF point.

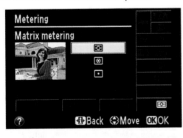

‹ The metering pattern can be selected from the Information Display.

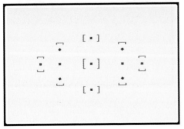

‹ The coverage of the Matrix metering pattern extends virtually to the edge of the frame area, as shown by the yellow shading.

To derive the most from Matrix metering, use a D- or G-type Nikkor lens, as these provide focus-distance information coupled with information as to which AF point is reporting focus. This enables the camera to estimate how far away, and where within the frame area, the subject is located. By integrating this data into the exposure calculations, exposure accuracy is improved. Nikon refers to this system as 3D Color Matrix Metering III.

If an AF or Ai-P type lens that does not communicate distance information to the camera is used, the system simply defaults to standard Color Matrix Metering III (i.e., the distance information is not integrated into the exposure computations). TTL metering is not available with the D3200 if a non-CPU-type lens is attached to the camera.

CENTER-WEIGHTED METERING

75% of the exposure reading is based on a central 8-mm area of the frame, with the remaining 25% based on the outer frame area. Unlike Matrix metering, no color information is assessed when the Center-Weighted pattern is selected, so metering is based on a grayscale distribution of tones.

> Here you can see the coverage of the Center-Weighted metering pattern.

SPOT METERING

Highly specific, this pattern covers a circle approximately 0.16 inch (3.5 mm) in diameter, which represents about 2.5% of the total frame area. The metered area is centered on the active AF point unless Auto-Area AF is selected or a non-CPU lens is used, in which case, the central AF point is the only area to perform metering. No color information is assessed, so metering is based on a grayscale distribution of tones.

> This image illustrates the coverage of the Spot metering pattern.

HINT: In Center-Weighted and Spot metering, the D3200 is calibrated to produce a proper exposure when the metered area is a midtone. If the metered area is lighter or darker than a midtone, it will be necessary to compensate the exposure value suggested by the camera.

The D3200's autofocus system uses the Nikon Multi-CAM 1000DX AF sensor with an array of eleven points, of which one is a cross-type sensor (the center point) and ten are line-type sensors. Of the outer ten AF points, those above and below the center AF point are oriented parallel to the long edge of the frame, so they most effectively focus on details in the scene that run parallel to this line. Those on the mid-line of the frame to the left and right of the center AF point are oriented parallel to the short edge of the frame, so they most effectively focus on details in the scene that run vertically. The remaining four AF points are aligned diagonally, and are most effective with detail that is parallel to their alignment. The D3200 integrates information from its Scene Recognition System (SRS) (which maps color, tone, and contrast on the RGB metering sensor to assist in subject identification), and it assess its location to further enhance the AF system.

‹ The AF point at the center of the AF area (shown in red) is a cross-type sensor, while the remaining ten points (shown in green) are line-type sensors. The color shading is for illustrative purposes only, to indicate the approximate coverage of each AF point.

HINT: One of the most common causes of inaccuracy when using the AF system is the size of the subject relative to the area of the AF point. If the size of the area being focused on is small compared to the area covered by the AF point (as is often the case when using a wide-angle lens), the AF system is likely to miss the intended focus point. As a general rule, make sure that the subject covers at least 50% of the area covered by the AF point.

HINT: Sometimes, when using one of the line-type sensing areas, the autofocus system will "hunt" (i.e., the camera will drive focus back and forth but be unable to attain focus). This is often an indication that the detail in the subject is not aligned with the AF point, and there is insufficient contrast for the AF system to acquire focus. If this occurs, try tilting the camera slightly (10 – 15°) so that the focus-sensing area can detect more contrast in the subject. Once focus is confirmed, lock it and recompose the picture before releasing the shutter.

AUTOFOCUS MODES USING THE OPTICAL VIEWFINDER

With the viewfinder, the D3200 uses a phase-detection focusing method and has has three principal focusing modes: Single-Servo AF (AF-S), Continuous-Servo AF (AF-C), and Manual focus (MF). A further option, Auto-Servo AF (AF-A) will automatically select either AF-S if the camera determines the subject is stationary, or AF-C if the subject is moving.

NOTE: AF-S and AF-C are only available in P, S, A, and M exposure modes; in Auto, Auto (Flash Off), and Scene modes, only AF-A or MF can be selected.

› The AF mode is selected from the Information Display.

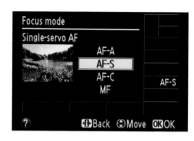

To select the focus mode, press the ⦿ button to open the Information Display, and press it again to show the highlighted cursor. Highlight the focus mode and press ⊗. Highlight the required option and press ⊗ to select it. Press the shutter release button down halfway to return to the shooting mode.

AF-S (Single-Servo): In this mode, focus is activated when the shutter release button is pressed down halfway, or if the AE-L/AF-L button is pressed when the AF-ON option has been selected via **[Buttons] > [Assign AE-L/AF-L button]** in the Setup menu. As soon as focus is acquired, the in-focus indicator ● is displayed in the viewfinder; the shutter can only be released once focus is confirmed. Focus will remain locked while the shutter release is held halfway down, or while the AF-ON button is held down. No form of focus tracking is performed in this AF mode; therefore, it is best suited to photographing stationary subjects where the camera-to-subject distance remains constant.

AF-C (Continuous-Servo): In AF-C mode, the camera focuses the lens continuously when the shutter release button is pressed down halfway, or if the AE-L/AF-L button is pressed when the AF-ON option has been selected via **[Buttons] > [Assign AE-L/AF-L button]**. If the camera-to-subject distance changes, such as if the subject begins to move, the camera will track it and shift focus accordingly. Since focus is monitored constantly, it does not matter whether the subject continues to move or stops and starts periodically; the camera will continue to focus until either the shutter fires, or the either the shutter or AF-ON button is released. AF-C mode is ideal for photographing moving subjects.

M (Manual Focus): In this mode, the focus ring of the lens must be turned to achieve focus. There is no restriction on when the shutter can be released; it will fire whether or not focus has been achieved. With a lens that has a maximum aperture of f/5.6 or larger, the electronic rangefinder feature will display the in-focus confirmation signal ● when focus is achieved.

^ Choice of AF mode should be based on whether or not the subject is moving. Use AF-C (Continuous-Servo) in cases like this, with knights rapidly charging each other on horseback.

AF-S AND AF-C – WHAT IS THE DIFFERENCE?

It is important to appreciate the significant differences between the AF-S (Single-Servo) and AF-C (Continuous-Servo) modes. In AF-S mode, the shutter cannot be released until focus has been acquired; Nikon refers to this mode as having "focus priority." Once focus is acquired, the focus distance is locked. In most shooting conditions, waiting for the camera to acquire focus is of no practical consequence. However, under certain conditions, such as in low light or with low-contrast subjects, there can be a discernable lag when establishing focus, particularly if one of the outer, line-type sensing areas is used.

Conversely, in AF-C mode, the shutter can be released at any time, even if the in-focus indicator is not displayed in the viewfinder; Nikon refers to this mode as having "release priority." It is natural to assume that if the shutter is released before the camera has indicated that it has acquired focus in the AF-C mode, the picture will be out-of-focus. In actuality, however, the combination of continuous focus monitoring and Predictive Focus Tracking (see next section), which is engaged when the camera detects a moving subject, is normally successful in causing the focus point to be shifted within the split-second delay between the reflex mirror lifting and the shutter opening to obtain a sharp picture. To maximize AF performance when using AF-C mode to photograph a moving subject, it is imperative that the camera be given sufficient time to assimilate information to perform the focusing action. To do this, press and hold the shutter release button halfway (or press and hold the AF-ON button) as far in advance of releasing the shutter as possible.

PREDICTIVE FOCUS TRACKING

In AF-C mode, the D3200 uses its Predictive Tracking system to shift the point of focus to allow for the change in camera-to-subject distance, regardless of whether the subject is moving at a constant speed, accelerating, or decelerating during the short delay between the reflex mirror lifting and the shutter opening. When the shutter release button is held down halfway, or the AF-ON button is pressed in AF-C mode, Predictive Focus Tracking is initiated automatically whenever the camera detects that the camera-to-subject distance is changing, whether the change occurs while the camera is establishing focus or after focus is first acquired.

AUTOFOCUS-AREA MODES

The D3200 has four autofocus-area modes (not to be confused with the AF modes) that determine how the eleven AF points operate. To select an AF-Area mode, press the ᐃ button to open the Information Display, and press it again to show the highlighted cursor. Highlight AF-Area mode and press ⊗. Highlight the required option and press ⊗ to select it. Press the shutter release button down halfway to return to the shooting mode.

> The AF-Area mode is selected from the Information Display.

> The black lines marked on the focus screen define the AF Area. Here, in Single-Point AF, when the center point is selected, it will be displayed briefly highlighted in red.

[⊡] **Single-Point AF:** In this AF-Area mode, only a single, manually selected AF point is used for focusing; the camera takes no part in choosing which AF point to use. The selected AF point is highlighted in the Information Display.

NOTE: Single-Point AF mode is selected automatically when the D3200 is set to Manual focus.

[⊙] **Dynamic-Area AF:** In AF-C mode only (including if it is selected by AF-A), when Dynamic-Area AF is selected, focus is based on whichever AF point you have selected. However, if the subject briefly leaves the area covered by this AF point, the camera makes an immediate evaluation from surrounding AF points in an attempt

to maintain focus by using these points as appropriate until the subject returns to being covered by the AF point you originally selected. The initially selected point remains highlighted in the viewfinder even if another point is used momentarily to maintain focus. In AF-S mode, the camera only uses the AF point you select—the camera does not perform automated selection of alternative AF points.

[3D] **3D-Tracking AF:** In AF-C mode only (including if it is selected by AF-A), when you select 3D-Tracking AF, focus is based on whichever AF point you select. However, if the subject leaves the area covered by this AF point, the camera will track the subject, selecting alternative AF points as required. This option is most effective when the camera-to-subject distance remains fairly constant and the subject is moving laterally across the frame, or when you quickly change the composition to move the subject from one side of the frame to the other. If the subject moves out of the viewfinder, it will be necessary to reacquire focus by placing the selected AF point over the subject and activating AF again.

> **NOTE:** In 3D-Tracking AF, the colors in the frame around the AF point are stored and mapped by the camera. Consequently, if the subject and background have the same or a very similar color to one another, focusing accuracy is likely to be impaired.

[▦] **Auto-Area AF:** In this mode, the camera selects the AF point(s) automatically using information from the autofocus sensor and the Scene Recognition System as long as a D- or G-type Nikkor lens is used. It is particularly adept at identifying skin tones, and will give focus priority to a face if it detects one. All the active AF points are highlighted briefly in red, and then they turn off.

> **HINT:** As you change the AF-Area mode from Single-Point to Dynamic-Area to 3D-Tracking, and finally to Auto-Area, you relinquish more control to the camera in the selection of the AF point. Consider the most appropriate option based on the nature of the subject you are photographing and whether or not it is moving. For static subjects, use AF-S mode with Single-Point AF. For subjects that move in a predictable direction, use AF-C mode with its Predictive Focus Tracking in combination with Dynamic-Area AF. For a subject that moves unpredictably, or for cases where you need to recompose rapidly while maintaining focus, use the AF-C mode with the 3D-Tracking option. Finally, for point-and-shoot style photography, especially with people in the scene, consider the Auto-Area AF (as long as you are using a D- or G-type Nikkor lens).

FOCUS LOCK

Once you have acquired focus, it is possible to lock the autofocus system so that the shot can be recomposed and focus distance will be retained, even if the AF point no longer covers the subject. In AF-S mode, pressing the shutter release button halfway will activate autofocus. As soon as focus is acquired, the in-focus indicator ● is displayed in the viewfinder and focus is locked. It will remain locked as long as either button remains pressed. Alternatively, when one of the focus lock options has been selected for the **AE-L/AF-L** button via [Buttons] > [Assign AE-L/AF-L button], press and hold the **AE-L/AF-L** button to lock focus. Once

focus is locked using the AE-L/AF-L button, it is not necessary to keep the shutter release button depressed.

In AF-C mode, AF remains active, constantly adjusting focus as necessary, as long as the shutter release button is held halfway down. To lock focus, press and hold the AE-L/AF-L button; once focus is locked, it is not necessary to keep pressing the shutter release button or the AF-ON button. In either AF-S or AF-C mode, ensure that the camera-to-subject distance does not change. If it does, reactivate autofocus and refocus the lens at the new distance.

A popular technique that provides flexible control of the AF system is to decouple the activation of the autofocus from the shutter release button by selecting the [AF-ON] option via [Buttons] > [Assign AE-L/AF-L button]. The camera can be left in AF-C mode and autofocus can be switched on by pressing the AF-ON (AE-L/AF-L) button. Once focus is acquired, release the AF-ON button, locking the focus distance. The picture can be recomposed, as the focus distance will not change even if the shutter release button is pressed. If the camera-to-subject distance changes, or the subject begins to move, place the selected AF point over the subject, and press the AF-ON button to switch autofocus on; Predictive Focus Tracking will engage automatically if required.

AF-ASSIST ILLUMINATOR

The D3200 has a small, built-in AF-Assist lamp that is designed to facilitate autofocus in low-light conditions. Its operation is controlled via the [Built-in AF-assist illuminator] item in the Shooting menu. However, it is of limited use for the following reasons:

o The lamp only works when all of the following are true: an autofocus lens is attached to the camera, AF-S mode is selected or Single-Servo AF is selected via AF-A mode in viewfinder photography, and either Auto-Area AF is set or an AF-Area mode option other than Auto-Area AF is set and the center AF point is selected.

o It is only usable with focal lengths of 18mm – 200mm.

o The operating range is only 1.7 – 9.8 feet (0.5 – 3.0 m).

o Due to its location, many lenses obstruct its output, particularly if they have a lens hood attached.

o The lamp overheats quite quickly (six to eight exposures in rapid succession is usually sufficient) and will automatically shut down to allow it to cool.

o At this level of use, it also drains the battery power faster.

LIMITATIONS OF AUTOFOCUS

Although the autofocus system of the D3200 is very sophisticated and highly effective, there are some conditions that can impair or limit its performance:

o Low-ambient-light conditions.

o Low-contrast ambient light or low subject contrast.

o Highly reflective surfaces.

o Subject too small within the area covered by the AF point(s).

o The AF point covers a subject comprising very fine detail.

o The AF point covers a regular geometric pattern.

o The AF point covers a region of high contrast.

o The AF point covers objects at different distances from the camera.

If any of these conditions prevent the camera from acquiring focus, either switch to Manual focus or focus on another object at the same distance from the camera as the subject and use the focus lock feature before recomposing the picture.

WHITE BALANCE

SELECTING A WHITE BALANCE OPTION

To select white balance in P, S, A, and M exposure modes, press the ⏻ button to open the Information Display, and press it again to show the highlighted cursor. Highlight the white balance setting and press ⊛. Highlight the required option and press ⊛ to select it. Press the shutter release button down halfway to return to the shooting mode. Alternatively, navigate to the [White balance] item in the Shooting menu. (You must go the menu route to select the bulb-type options for [Fluorescent].)

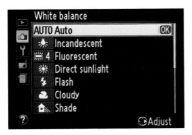

‹ To access the full range of options and levels of control for white balance, use the [White balance] item in the Shooting menu.

NOTE: It is possible to assign selection of the white balance setting to the Function (Fn) button by selecting the [White balance] option via [Buttons] > [Assign Fn button] in the Setup menu.

The D3200 has eight principal white balance options:

A **Automatic (3500 – 8000K):** This selection sets the white balance automatically. There are two sub-options: [Normal] and [Keep warm lighting colors]. These can only be selected via [White balance] > [Auto] in the Shooting menu.

Incandescent (3000K): Use this for shooting under typical incandescent lighting.

Fluorescent (2700K – 7200K): Select when shooting under fluorescent lighting. There are seven sub-options (see the chart on next page), accessible via [White balance] > [Fluorescent] in the Shooting menu.

BULB TYPE	COLOR TEMPERATURE	SHOOTING MENU DISPLAY
Sodium-vapor lamps	2700	☼ 1
Warm-white fluorescent	3000	☼ 2
White fluorescent	3700	☼ 3
Cool-white fluorescent	4200	☼ 4
Day-white fluorescent	5000	☼ 5
Daylight fluorescent	6500	☼ 6
High temp. mercury vapor	7200	☼ 7

☀ **Direct sunlight (5200K):** When shooting in direct sunlight, choose this option.

⚡ **Flash (5400K):** When your scene is primarily lit by flash, make this selection.

☁ **Cloudy (6000K):** The Cloudy setting is the way to go for pictures shot outdoors under overcast skies.

⌂ **Shade (8000K):** When shooting outdoors in the shade, particularly open shade under clear blue skies, the Shade selection is the ideal choice.

PRE **Preset manual:** Here, you can set a white balance value manually from a neutral or white test target or, alternatively, using a white balancing device. See below for more information.

PRESET MANUAL WHITE BALANCE

The [Preset manual] option allows you to set white balance manually, either by measuring light reflected from a white or neutral reference target, or using the white balance value from a picture saved to a memory card in the camera. The D3200 can store only one value for [Preset manual]; the stored value is overwritten when a new value is measured.

HINT: Nikon suggests using either a white or neutral gray card for [Preset manual]. I recommend that you stick with a neutral gray card, as white cards often contain pigments used to brighten them, which can skew the white balance.

HINT: As an alternative to using a piece of card as the reference target for [Preset manual], there are a number of products that can be attached directly to the front of the lens and allow the camera to not only obtain a white balance measurement, but also take an incident light reading, such as the ExpoDisc (www.expodisc.com).

To set a value for [Preset manual] under the prevailing light, place a neutral gray reference target in the same light. Exposure is increased automatically by 1.0 EV during the measurement phase of [Preset manual]. (In M mode, adjust the exposure scale to show ±0.0.)

Press the MENU button and open the Shooting menu, then highlight [White balance] and press ▶, and highlighted [Preset manual]. Highlight [Measure] and press ▶. Next, a warning dialog is displayed, highlight [Yes] and press ⓞ. An instruction message is displayed, and when the camera is ready, *PrE* flashes in the viewfinder and Information Display (this will occur for approximately 6 seconds). Point the camera at the reference target (make sure you do not cast a shadow over it) and make sure that it fills the viewfinder frame (there is no need to focus on the test target card), then press the shutter release.

If the camera is able to set a white balance value, *Ld* will appear in the viewfinder and blink for approximately 8 seconds. The value will be stored by the camera, and replace any value saved previously. If the camera is unable to set a value, typically because the light level is either too low or too high, *noLd* will appear, blinking in the viewfinder. In this case, press the shutter release down halfway, and repeat the process.

To copy the white balance from an existing picture, press the MENU button and open the Shooting menu, then highlight [White balance] and press ▶, and highlight [Preset manual]. Highlight [Use photo] and press ▶. Highlight [Select image] and press ▶ (to use the last image used for setting the Preset white balance, select [This image]), and highlight the folder containing the source image, before pressing ▶. Highlight the required image (a narrow yellow border will surround it), then press and hold ⚲ to view the image full frame. Finally, press ⓞ to copy the white balance value from the selected image.

FINE-TUNING WHITE BALANCE

White balance values can be fine-tuned to compensate for variations in the color temperature of a particular light source, or to create a deliberate colorcast in a picture.

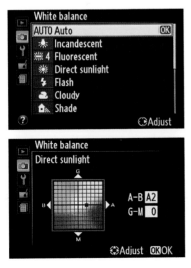

‹ Highlight the [White balance] item in the Shooting menu and press ▶ to display the fine-tuning controls.

‹ This is the display for fine-tuning the [Direct sunlight] setting. Here, an amber hue will be applied to produce a warmer color rendition.

To fine-tune white balance, navigate to the [White balance] item in the Shooting menu, and press ▶. Highlight the required option, then press ▶ to display a color graph. The horizontal axis is used to fine-tune the level of amber (A) to blue (B), while the vertical axis is used to adjust the level of magenta (M) to green (G). Once the fine-tuning adjustment is set, press the ⊛ button to apply it and return to the Shooting menu. A white balance value that has been fine-tuned is marked with an asterisk.

NOTE: The colors on the axes of the color graph are relative and not absolute. So, for example, shifting the cursor toward A (amber) will make the picture slightly warmer, but will not result in a strong amber color cast.

NOTE: To apply fine-tuning to the [Fluorescent] white balance, first select a bulb type and press ▶. Fine-tuning is not available with the Preset Manual setting.

LIVE VIEW PHOTOGRAPHY

Live View provides a real-time video signal from the main imaging sensor to the monitor to show the view of the lens. It enables pictures to be composed when using the optical viewfinder is either difficult or not desirable. For example, Live View may be the preferred choice when the enlarged view offered by the monitor will help with composition, or for checking focus. Live View uses contrast-detection autofocus, with the advantage that the focus point can be positioned anywhere within the area of the frame. However, it is slower than the phase-detection autofocus used when shooting pictures via the optical viewfinder.

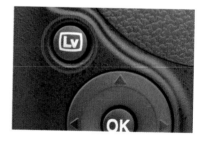

> Live View is accessed via the Ⓛⓥ button above the Multi Selector on the back of the D3200.

USING LIVE VIEW

To activate Live View, press the Ⓛⓥ button; the reflex mirror will lift and the view through the lens will be displayed on the LCD monitor, together with the Live View Information Display and the AF point. To scroll through the Live View Information Display options (see next page), press the 🅸🅽🅵🅾 button.

To shoot pictures from Live View, position the AF point over the subject, and then press the shutter release button down halfway. The AF point will blink during focusing and turn green when focus is acquired. If the camera cannot focus, the AF point will blink red. To take a picture, press the shutter release button down fully. The monitor will go blank, and once the image has been recorded, it will be displayed on the monitor briefly, or until the shutter release button is pressed

down halfway. The camera will then return to its Live View mode. Press the ⓁⓋ button to exit Live View.

NOTE: To lock exposure in Live View, press the **AE-L/AF-L** button. To lock focus, keep the shutter release button pressed down halfway.

NOTE: If Live View is selected in 📷 or ⓑ mode, Automatic Scene Selection is activated and the camera assess the subject / scene and selects what it considers to be the most appropriate shooting mode. The selected mode, which can be chosen from Auto, Auto (flash off), Landscape, Close Up, or Night Portrait, is shown in the Information Display.

THE LIVE VIEW INFORMATION DISPLAY

The Live View Information Display shows a range of data on the monitor, including a countdown timer that will commence from 30 seconds before Live View is due to end automatically.

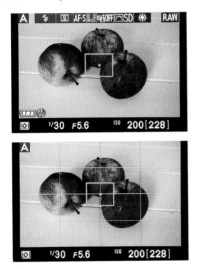

‹ The Live View Information Display.

‹ The Live View Framing Grid display.

Four displays can be selected by pressing the 🅸🅽🅵🅾 button during Live View:

- O **Show photo indicators:** This option displays the following: AF mode, AF-Area mode, Active D-Lighting, Picture Control setting, white balance, image size, image quality, metering pattern, exposure mode, shutter speed, aperture, ISO, exposure compensation, and the number of shots remaining (at current settings).
- O **Show movie indicators:** This option displays the following: frame size, frame rate, AF mode, AF-Area mode, white balance, exposure mode, microphone level, time remaining (at current settings) ISO, exposure compensation.
- O **Hide indicators:** This option hides all the information shown within the image area of the Live View display, except the exposure mode and the 16:9 ratio framing marks, leaving only the information at the bottom of the monitor visible.
- O **Framing Grid:** This option overlays the screen with a grid pattern to facilitate framing and composition.

General points to consider when shooting pictures in Live View:

O Since the sensor is exposed continuously during Live View, never point the camera directly at the sun or any other high-intensity light source; otherwise, the sensor may be damaged.

O In P, S, and A modes, exposure can be adjusted by ±5 EV in steps of 0.3 EV, although the effects of values beyond ±3 EV will not be shown on the monitor.

O Matrix metering is used regardless of the metering pattern selected for photography via the optical viewfinder.

O To magnify an image in Live View to assist in precise focusing, press the ⚲ button (the maximum magnification is approximately 9.4x). Press the ⚲ button to reduce magnification. A navigation window will be displayed in the LCD monitor, and you can then use the Multi Selector to scroll to other areas of the frame.

O It is important to block light from entering the viewfinder eyepiece when shooting in Live View, as it may influence the TTL metering and affect the final image. Always cover the viewfinder eyepiece with the supplied DK-5 accessory when using Live View.

O A countdown is displayed for 30 seconds before Live View is set to end automatically. The display turns red 5 seconds before the end of the countdown period. Automatic Live View shutdown occurs to prevent the sensor from overheating and protect the camera from thermal damage; the countdown timer may even appear immediately when Live View is activated, especially in conditions of high ambient temperature, or if the camera has already been used for protracted periods in Live View.

O You may observe bands of flickering in the Live View image under certain types of artificial lighting, such as fluorescent lighting. Use the [Flicker reduction] item in the Setup menu to help reduce this effect.

LIVE VIEW AUTOFOCUS

To select the focus mode in Live View, press the ⏺ button to open the Information Display, and show the highlighted cursor. Highlight focus mode and press ⊛. Highlight the required option and press ⊛ to select it. Press either the shutter release button down halfway, or press the ⏺ button to return to the shooting mode. The following options are available:

O AF-S **Single-servo AF:** Used for stationary subjects, focus is adjusted and locked when the shutter release button is pressed halfway down.

O AF-F **Full-time servo AF:** Used for moving subjects, focus is adjusted continuously until the shutter release button is pressed. Focus locks when the shutter-release button is pressed halfway down.

O MF **Manual focus:** Focus the lens manually.

To select an AF-area mode in Live View (except in 🏠 and 🌷 modes), press the ⏺ button to open the Information Display, and show the highlighted cursor. Highlight focus mode and press ⊛. Highlight the required option and press ⊛ to select it. Press either the shutter release button down halfway, or press the ⏺ button to return to the shooting mode. The following options are available:

O 👤 **Face-Priority AF:** The D3200 will detect the face of a person and focus on it automatically. The AF point, which will have a double yellow border, identifying the selected face. If there are multiple faces (the camera can detect up to 35), it will focus

on the face closest to the camera (or you can use the Multi Selector to shift the AF point to another face). Press the shutter release down halfway to focus, and the AF point will turn green if focus is acquired. If the subject turns their face so it is no longer visible to the camera, the double border AF point will not be displayed (a face usually needs to be square to the lens for detection to occur). The AF point is shown as a single border red square before focus is acquired; the square turns green when the subject is in focus.

o ⌗ **Wide-Area AF:** This AF-area mode is ideal for handheld picture taking of large subjects, as the AF point covers a large area of the frame. Use the Multi Selector to shift the AF point to the required position. Initially, the AF point is displayed as a red square. Press the shutter release down halfway to focus; the AF point will turn green if focus can be acquired, or blink red if not. To center the AF point press ⊛.

o **Normal-Area AF:** Use this option for precision focus on a very specific point. It is best suited for shooting from a tripod and is particularly useful in close-up photography. Positioning the AF point and its appearance when achieving focus are the same as for Wide-area AF, described above.

o ⊞ **Subject-Tracking AF:** The D3200 will attempt to track a selected subject as it moves within the frame; it is most effective when combined with AF-F mode in a situation where the camera-to-subject distance remains fairly constant (i.e., the subject only moves laterally across the frame). In this AF-area mode, the AF point is displayed as a square with four additional corner markings. Place it over the subject. In AF-F mode, the camera will focus automatically and the AF point will be displayed in green when focus is acquired, or be shown in red if the camera cannot focus. In AF-S mode, the AF point is shown initially in white, and it is necessary to press the shutter release button down halfway to activate focusing; the AF point will turn green when focus is acquired. Next press ⊛ and the focus point will now track the subject if it changes position within the frame area. To end tracking, press ⊛ again.

NOTE: Subject tracking is unlikely to cope with a subject that is very small in the frame, one that is moving quickly (especially toward/away from the camera), is similar in tone/color to the background, is very bright/dark, or one that changes size significantly. If the subject leaves the frame area it will be necessary to reacquire focus.

LIVE VIEW MOVIE

In addition to shooting pictures from Live View it is also used in the camera's Movie mode to record video. Activate Live View by pressing the ⌷ button. The reflex mirror will lift and the view through the lens will be displayed on the LCD monitor together with the most recently selected Live View Information Display option and the AF point (its appearance varying according to the option selected for Live View AF-area mode). If ▦ is displayed on the monitor, it is not possible for the D3200 to record a video. Scroll through the Live View Information Display options by pressing the ⓘ button until the [Show movie indicators] display is shown.

The choices and selection of focus modes and focus-area modes for Live View Movie mode, together with the focusing procedures, are the same as those described in the previous Live View Autofocus section. In AF-S focus mode, the shutter release button must be pressed down halfway to activate focusing; in AF-F mode, the camera will focus automatically on the section of the scene covered by the AF point.

^ The ability to isolate a subject by using a very shallow depth of field is one of the great advantages of recording video on a DSLR.

Settings for [Frame size/frame rate], [Movie quality], [Microphone], and [Manual movie settings] are accessed via the [Movie settings] item in the Shooting menu, and must be set before entering Live View (see below). Likewise, the options for [Set Picture Control] in the Shooting menu, and the lens aperture must be selected before video recording begins.

Exposure is always set using Matrix metering in Live View, regardless of the option selected within the Information Display. Unless [On] is selected for [Manual movie settings] and the camera is set to M (manual) exposure mode, the D3200 will adjust shutter speed and ISO automatically, providing fully automated control of the exposure level; however, except in ⏱ and ⚘ modes, pressing the **AE-L/AF-L** button locks exposure, while in P, S, and A modes, exposure can be adjusted ±3.0 Ev in steps of 0.3 Ev using exposure compensation.

MOVIE SETTINGS

The options within the [Movie settings] item enable the user to exercise control over the D3200 when recording video, particularly useful is the option to set the shutter speed and ISO manually via the [Manual movie settings] item, as this will ensure a consistent appearance to the recording, assuming the nature of the lighting does not alter. If you rely on the automated exposure control, the adjustment applied by the camera will likely result in noticeable shifts in brightness of the recording, which are distracting. Likewise, I recommend you avoid using the built-in microphone, as it picks up every sound made by the camera, such as adjusting focus and operation of Vibration Reduction, together with any noise made by the user handling the camera. The D3200 has a 3.5 mm jack terminal for connecting an external stereo

microphone, such as the optional Nikon ME-1. Using such a device will make a significant improvement to the audio record you can obtain with the camera, in conjunction with the controls offered by the [Microphone] item within the [Movie settings] item. For best results I recommend using [Manual sensitivity] in most situations to produce a consistent recording level, particularly in situation where the sound being recorded varies in volume naturally.

FRAME SIZE/FRAME RATE AND MOVIE QUALITY

FRAME SIZE (PIXELS)	FRAME RATE [1]	MAXIMUM BIT RATE (MBPS) - HIGH QUALITY / NORMAL	MAXIMUM CLIP LENGTH
1920 x 1080	30p [2]		
	25p [3]		
	24p	24 / 12	
1280 x 720	60p [2]		20 minutes
	50p [3]		
640 x 424	30p [2]	5 / 3	
	25p [3]		

1 Actual frame rates for 60p, 50p, 30p, 25p, and 24p, are as follows: 59.94, 50, 29.97, 25, and 23.976 fps respectively.
2 Frame rate available when [NTSC] is selected for [Video mode]
3 Frame rate available when [PAL] is selected for [Video mode]

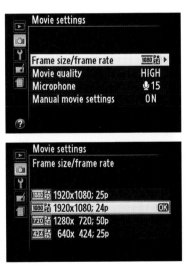

< This is the [Movie settings] item in the Shooting menu.

< Select from the [Frame size/frame rate] options available for movie recording.

MICROPHONE

Use this item to control the built-in, or an optional external microphone:

 O [Auto sensitivity]: the camera controls the recording level automatically.

 O [Manual sensitivity]: the recording level is set to a fixed value.

 O [Microphone off]: audio recording is switched off.

MANUAL MOVIE SETTINGS

The secret to success with recording video is consistency of exposure and using an appropriate shutter speed to render a specific amount of motion blur when recording a moving subject, or panning the camera so successive frames blend in to each other. If the shutter speed is too slow the video will appear smeared, while at fast shutter speeds it will appear with a stuttered (staccato) effect; therefore, it is important that the frame rate is synchronous to the shutter speed. Use the [Manual movie settings] item in conjunction with M exposure mode to set the shutter speed to a fixed value. For frames rates of 50p, 25p, and 24p, use a shutter speed of 1/50; for frame rates of 60p and 30p, use 1/60 s.

For consistent exposure level, set the camera to M (manual) exposure mode and select [On] for [Manual movie settings] to enable manual control of the shutter speed and ISO settings. The shutter speed can be set to a fastest value of 1/4000 s, while the slowest value will depend on the frame rate, as follows: at 24p, 25p, and 30p it is 1/30 s, at 50p it is 1/50 s, and at 60p it is 1/60 s. The ISO can be set to any value between 200 and Hi 1 (12,800); the value is fixed at the selected level and will not be adjusted by the camera, even if [On] is selected for [Auto ISO sensitivity control] in the Shooting menu. If the shutter speed and ISO values are out side these ranges when the Ⓛⱽ button is pressed, the camera will adjust them automatically to values that are supported within this menu item.

RECORDING A MOVIE

To start recording, press the Record button. A recording indicator and the available recording time will be displayed in the monitor. To end recording, press the Record button again. Press the Ⓛⱽ button to exit Live View. The maximum recording duration for a single clip is approximately 20 minutes, with a maximum file size of 4GB. A countdown is displayed for 30-seconds before the recording ends.

NOTE: Still photographs can be taken during video recording by pressing the shutter release button all the way down. Video recording will end immediately, with the video recorded up to that point being saved by the camera. The camera will then return to Live View Movie mode.

NOTE: At a frame size other than 640 x 424, all video recordings have an aspect ratio of 16:9; when [Show movie indicators] is selected for the Live View Information Display, the area outside the 16:9 crop is grayed out.

The Menu System

The control of many of the D3200 features and functions relies on an extensive and comprehensive menu system. Press the MENU button to display a list of all menu tabs in the left column of the LCD monitor (the current menu page will also be open). Press ◀ to choose from among the five tabs in the left column, and then ▲ or ▼ to highlight the desired menu and open its page. Press ▶ to highlight a menu item; press ▲ or ▼ to scroll to different menu items. Press ▶ again to display the options available for the menu item, and press ▲ or ▼ to highlight the required the option. Press the ⊛ button to confirm a selection (generally, pressing ▶ has the same effect as pressing ⊛; however, some options can only be selected by pressing ⊛). To exit the menu system, press the shutter release button down halfway.

Throughout the remainder of this chapter, when you need to access a menu, I will instruct you as follows:

- o "Highlight the (NAME OF) menu." This means to highlight the tab of the required menu, and then press ▶ to enter the menu.
- o "Highlight the (NAME OF) item." In this case, press ▲ or ▼ to scroll to the required menu item.
- o "Select it." In this case, press ▶ to display the options for a menu item, or if the required option is highlighted, press ⊛ to select it.

NOTE: If a menu option is displayed in grey, it is not available. This can occur for one of a number of reasons including: the current camera settings, the state of the memory card, or the battery's charge status.

> The main Playback menu not only allows you to review recorded images, but also display information about them, such as the histogram and shooting information. The photos can also be played in slide show with transition effects.

PLAYBACK MENU	
Delete	🗑
Playback folder	D3200
Playback display options	--
Image review	OFF
Rotate tall	ON
Slide show	--
DPOF print order	🖪
?	

▶ THE PLAYBACK MENU

The Playback menu is used to review, edit, and manage the pictures stored on the memory card.

DELETE

This item is used to delete either a group of images or all the images in the folder currently selected for Playback.

To delete a group of images:
1. Highlight the [Delete] item and select it.
2. Highlight [Selected] and select it.
3. Thumbnails images are displayed six at a time. Use the Multi Selector to navigate through them; a yellow frame is shown around the selected image. To see an enlarged view, press and hold the ⊕ button.
4. Press the ⊕ button to choose the image for deletion; 🗑 will appear in the image. To deselect a picture, press the same button again.
5. Press the ⊛ button to show the number of images to be deleted and a confirmation.
6. Highlight [No] to cancel and [Yes] to confirm; press ⊛ to complete the process.

To delete all images taken on a selected date:
1. Highlight the [Delete] item and select it.
2. Highlight [Selected date] and select it.
3. Highlight the required date. Press the ⊕ button to view up to six thumbnails images at a time; a yellow frame is shown around the selected image. To see an enlarged view, press and hold the ⊕ button. Press the ⊕ button again to return to the list of dates. Press the Multi Selector to the right to select the date, and place a check mark next to it.
4. Repeat step 3 for other dates.
5. Press the ⊛ button to display a confirmation.
6. Highlight [No] to cancel and [Yes] to confirm; press ⊛ to complete the process.

To delete all images in the folder currently selected for playback:
1. Highlight the [Delete] item and select it.
2. Highlight [All] and select it.
3. Highlight either [No] or [Yes] and select it.
4. Press the ⊛ button to complete the process.

NOTE: It is not possible to delete pictures that have been protected.

PLAYBACK FOLDER

Use this item to determine which images will be displayed during Playback. There are two options:

- O **[Current]**: Only images in the folder currently selected for image storage via the option for **[Storage folder]** in the Setup menu can be viewed.

- O **[All]**: All images in all folders will be available during playback.

To select the Playback Folder:

1. Highlight the **[Playback folder]** item and select it.
2. Highlight the desired option.
3. Press ⊛ to confirm the selection.

PLAYBACK DISPLAY OPTIONS

This item determines the information displayed during single-image playback:

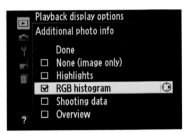

‹ Here, **[RGB histogram]** has been selected for **[Additional photo info]**; this is probably the most useful option as far as assessing exposure is concerned.

1. Highlight the **[Playback display options]** item and select it.
2. Highlight the **[Additional photo info]** item and select it.
3. Highlight the required option and select it.
4. Repeat step 2 to select another option.
5. Highlight and select **[Done]**.

To set the nature of the transition between the displayed images:

1. Highlight the **[Playback display options]** item and select it.
2. Highlight the **[Transition effects]** item and select it.
3. Highlight the required option and select it.

IMAGE REVIEW

This item determines if an image will be displayed on the monitor immediately after it is recorded. If **[Off]** is selected, the ▶ button must be pressed to display an image:

1. Highlight **[Image review]** and select it.
2. Highlight the required option and select it.

ROTATE TALL

This item determines the display orientation of vertical images. Images recorded with [Off] selected for [Auto image rotation] in the Setup menu will be displayed in the horizontal orientation regardless of what is set here.

1. Highlight the [Rotate Tall] item and select it.
2. Highlight [On] (image is rotated for display) or [Off] and select it.
3. Press ⊛ to confirm the selection.

SLIDE SHOW

This item allows viewing of all of the images in the current playback folder in sequential order:

› The options for the [Slide show] item

1. Highlight the [Slide show] item and select it.
2. Highlight [Image type] and select it; choose either 🗖🎥 to display stills and video, 🗖 to display stills only, or 🎥 to display videos only, and select it.
3. Highlight [Frame interval] and select it; choose 2, 3, 5, or 10 seconds and select it.
4. To set the nature of transition between stills pictures, highlight [Transition effects] and select it; highlight the required option and select it.
5. Highlight [Start] and press ⊛ to begin the display.

There are a variety of control options when the [Slide Show] function is active:

○ Press ◄ to return to previous image; press ► to skip to the next image.
○ Press ▲ or ▼ to display the information pages.
○ Press ⊛ to pause/resume the display; four options are shown: [Restart], [Frame interval], [Transition effects] or [Exit]; highlight the required option and select it.
○ Press the ⊕ button to increase the volume, and the ⊖ button to decrease the volume during video playback
○ Press the MENU button to exit and return to the Playback menu.
○ Press ▶ to stop the display and return to the Playback mode.
○ Press the shutter release button halfway to return to the Shooting mode.

At the end of the display, the same options will be shown as when the display is paused; highlight the required option and press ⊛.

DPOF PRINT ORDER

The D3200 supports the Digital Print Order Format (DPOF) standard that embeds an instruction set in the appropriate metadata fields of an image file. This allows you

∧ Print a specified image set directly from your memory card by using the D3200's [DPOF Print Order] feature.

to insert the memory card directly into any DPOF-compatible printer or commercial mini-lab printer and obtain a set of prints from the selected images automatically. Apart from the fact that you do not have to attach the camera to a compatible printer through a USB connection (although this approach can be used, too), this feature can be particularly useful if, for example, you are away from your home or office, as you can still produce prints from your digital files even if you do not have access to your normal printer. DPOF prints can be made by any DPOF-compatible printer.

To print the current DPOF print set saved to the installed memory card (see below for details of how to create a DPOF print set), turn the camera off and connect it via USB to a PictBridge compatible printer. Then turn the camera on and a PictBridge Playback display will appear in the D3200's monitor. Highlight [Print (DPOF)] and press ▶ to select it.

Alternatively, remove the memory card from the camera, insert it into a DPOF-compatible printer, and follow the instructions for the printer to make prints from the memory card instead of from the camera.

NOTE: If, after creating and saving the current print set, you modify it by deleting images using a computer or other device, it may not print correctly.

NOTE: Print set selections can only be made from JPEG format images stored on the memory card; if an image was shot using the NEF+JPEG option, only the JPEG image can be selected for printing. However, it is possible to create a JPEG copy of an NEF (RAW) file by using the [NEF (RAW) processing] item in the Retouch menu.

Creating a DPOF Print Order Set: To select images for printing using the DPOF feature, it is necessary to create a DPOF print order. Start by highlighting [DPOF print order] from the camera's Playback menu; the [Select/Set] option will be highlighted. Press ▶ to select it, and the camera will display a thumbnail of all the images stored on the inserted memory card, in groups of up to six.

Use the Multi Selector to scroll through the images, and press and hold 🔍 to see the highlighted image full-frame. To select the highlighted image for printing, hold down the ◖🔳 button and press ▲; the image is marked with 🖨, and the number of copies to be printed is set to [1]. To specify the number of copies of each image selected for printing, keep the ◖🔳 button pressed, and then use ▲ and ▼ to increase or decrease the number, respectively. Repeat this process for each image to be printed. To deselect a picture for printing, press ▼ when the number of prints is set to [1]. Once you've selected all the images you want to print, press the ⊛ button to save the selected group of images and display the options for data imprinting.

To imprint shooting data on the image, highlight [Print shooting data] and press ▶ to switch the option on or off. To print the date/time the image was recorded, highlight [Print date] and press ▶ to switch the option on or off. In both cases, a check mark will appear in the box to the left of the item title in the menu screen to indicate the option is set to [On]. To finish, save the print set order by highlighting [Done] and pressing ⊛.

NOTE: To print the [DPOF print order] when the camera is connected directly via USB to the printer, use the [Print (DPOF)] option in the PictBridge menu; however, the [Print shooting data] and [Print date] options are not supported, so in this case to print the date of recording of a picture in the print order, use the [Time stamp] option in the PictBridge menu.

To deselect the entire print set, highlight [DPOF print order] from the Playback menu and press ▶, then highlight [Deselect all?]. Then press ▶ and highlight the required option, [Yes] or [No], and press ⊛ to confirm the selection.

📷 THE SHOOTING MENU

Items in the Shooting menu determine how the camera will operate when recording photographs and/or video. Many of the controls available in this menu can be accessed more quickly via the camera's external buttons and the Information Display.

› This is the first page of the main Shooting menu screen.

SHOOTING MENU	
Reset shooting menu	--
Set Picture Control	▣SD
Image quality	FINE
Image size	▢
White balance	☀
ISO sensitivity settings	--
Active D-Lighting	ON
Auto distortion control	OFF

To restore default settings to the Shooting menu:

1. Highlight [Reset shooting menu] and select it.
2. Highlight [Yes] and select it.

The default settings are as follows:

OPTION:	DEFAULT:
Set Picture Control *	Standard
Image quality	JPEG Normal
Image size	Large
White Balance	Auto
White Balance (Fluorescent)	Cool-white
ISO Sensitivity (P, S, A, and M)	100
ISO Sensitivity (Other modes)	Auto
Auto ISO Sensitivity Control	Off
Active D-Lighting	On
Auto Distortion Control	Off
Color Space	sRGB
Noise Reduction	On
AF-area mode (Viewfinder in ✿ mode)	Single-point
AF-area mode (Viewfinder in ⚞ mode)	Dynamic-area
AF-area mode (Viewfinder in all other modes)	Auto-area
AF-area mode (Live View ⚞ ▥ ⚞ ⚞)	Face-priority
AF-area mode (Live View ⚞ P, S, A, M)	Wide-area
AF-area mode (Live View ✿)	Normal-area
Built-in AF-assist illuminator	On
Metering	Matrix
Movie Settings: Frame Size/Rate	**
Movie Settings: Quality	High Quality
Movie Settings: Microphone	Auto Sensitivity
Movie Settings: Manual movie settings	Off

* Picture Control settings are restored to their default settings.
** Default settings vary depending on the country of purchase.

The items listed in the following chart, which are not items in the Shooting menu, are also restored to their default settings when [Yes] is selected for [Reset shooting menu]:

OPTION:	DEFAULT:
Release mode (all shooting modes except ✷)	Single frame
Release mode (✷ Scene mode only)	Continuous
Focus point	Center
Flexible program	Off
AE-L/AF-L Button hold	Off
Focus mode: Viewfinder	Auto-servo AF
Focus mode: Live View / Movie	Single-servo AF
Flash sync mode: 🄰🅄🅃🄾 ✷ 🔅 🌼	Auto front-curtain sync
Flash sync mode: 🔅	Auto slow sync
Flash sync mode: P, S, A, M	Front curtain sync
Exposure compensation	Off
Flash compensation	Off

SET PICTURE CONTROLS

The D3200 has six Nikon Picture Controls, which are listed in the following chart. Base your selection on the type of photo your want to record.

> Here, the adjustments for the [Standard] Picture Control are shown at their default settings.

> Here, the adjustments for the [Monochrome] Picture Control are shown at their default settings.

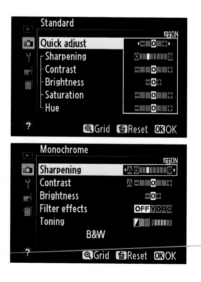

1. Highlight [Set Picture Control] and select it.
2. Highlight desired item and select it.

ITEM	SHARPENING (DEFAULT)	EFFECT
⊡SD Standard	3	Probably the most useful option for most shooting situations. Modest levels applied to image attributes such as color, saturation, and contrast.
⊡NL Neutral	2	Provides a good starting point for any image that will be subjected to extensive post-processing, as processing applied in camera is very restrained.
⊡VI Vivid	4	Useful for images that will be printed directly from the camera. Saturation and contrast are relatively high.
⊡MC Monochrome	3	Use for producing black-and-white images directly from the camera.
⊡PT Portrait	2	Color rendition is optimized for skin tones, while sharpening is reduced.
⊡LS Landscape	4	Saturation of blues and greens tends to be boosted, plus sharpening level is raised.

HINT: The Picture Control settings are only truly relevant for photographs when recording JPEG files; the Picture Control settings for NEF (RAW) files can be altered at will after the event in Nikon software. Regardless of the image editing application you use, the adjustment of contrast, saturation, brightness, and hue for NEF (RAW) files is best done in post-processing to achieve more refined modification.

Modifying a Picture Control: The six preset Nikon Picture Controls can be modified to fine-tune them to specific shooting situations.

1. Highlight [Set Picture Control] and select it.
2. Press ▶ to display the list of Picture Controls. Use ▲ or ▼ to select the desired option, then use ◀ or ▶ to adjust its value (a line is displayed beneath the previous value for the selected attribute).
3. Alternatively, highlight [Quick adjust] and use ◀ or ▶ to adjust a combination of settings.
4. Press 🗑 to restore default settings.
5. Press the ⊛ button to save the modified settings; the Picture Control is marked with an asterisk in the [Set Picture Control] menu.

NOTE: Press and hold the ⍤ button to display a chart of contrast and saturation in comparison to other Picture Controls (if the [Monochrome] option is selected only contrast is shown). Release the ⍤ button to return to the Picture Control menu.

The settings available for each of the Picture Control options is outlined in the following table:

OPTION	SETTINGS
Quick Adjust	Choose values between ±2 to reduce or increase the effect of the selected Picture Control. This option resets any manually adjusted settings; it is not available with Neutral, Monochrome, or any user-created Custom Picture Control.
ALL PICTURE CONTROLS	
Sharpening	A (auto), or a manually set value between 0 and 9. The higher the value, the greater the degree of sharpening.
Contrast	A (auto), or a manually set value between ±3. Use lower values to preserve detail in bright highlights, and use higher values to boost detail in low-contrast scenes.
Brightness	Choose values between ±1 to reduce or increase brightness (luminance) of an image.; this does not affect exposure.
ALL PICTURE CONTROLS EXCEPT MONOCHROME	
Saturation	A (auto), or a manually set value between ±3. Higher values make colors appear more vivid, while lower values reduce this effect.
Hue	Manually set value between ±3. Negative values make reds more purple, blues more green, and greens more yellow. Positive values make reds more orange, greens more blue, and blues more purple.
MONOCHROME PICTURE CONTROLS ONLY	
Filter Effects	Use to emulate the effects of contrast control lens filters used with traditional black-and-white photography. Red, orange, and yellow will increase contrast between a blue sky and white clouds. Green will reveal more skin tones.
Toning	Use to emulate the effect of chemical toners used in traditional black-and-white photography.

IMAGE QUALITY

This item determines the file type (format) when shooting still photographs and the degree of compression applied to JPEG files. The file type and amount of compression used will determine the image quality. For the highest image quality and greatest degree of flexibility in terms of working on your pictures in post-processing, use the NEF (RAW) option. However, these files will be considerably larger, typically 20MB each, compared with a JPEG file, so fewer pictures can be recorded to the memory card, and it will be necessary to perform some post-processing to produce a finished picture. If you wish to output pictures direct from the camera, and have no wish to deal with post-processing, the JPEG format is more convenient. The lower the amount of compression, the higher the image quality; but the file size will be larger, so fewer images can be saved to the memory card. If you expect to print your pictures, consider using the JPEG fine option, but for electronic publishing, the JPEG normal option should be suffice.

1. Highlight **[Image quality]** and select it.
2. Highlight the required option and select it.

OPTION	FILE TYPE	DESCRIPTION
NEF (RAW)	NEF	12-bit raw data from the image sensor is saved; settings such as color temperature, saturation, contrast, and hue can be changed subsequently at will.
JPEG fine		Saved at compression ratio of approximately 1:4 (high quality).
JPEG normal	JPEG	Saved at compression ratio of approximately 1:8 (normal quality).
JPEG basic		Saved at compression ratio of approximately 1:16 (low quality).
NEF + JPEG fine	NEF/JPEG	Two files saved: NEF and JPEG (high quality)

IMAGE SIZE

This item determines the file size (resolution) of an image in pixels; the options only apply to JPEG files; NEF (RAW) files are always recorded at the highest resolution.

1. Highlight **[Image size]** and select it.
2. Highlight the required option (see chart below) and select it.

SIZE	SIZE (PIXELS)
Large	6016 x 4000
Medium	4512 x 3000
Small	3008 x 2000

^ Noise can be an issue when using high ISO settings or long exposure times. The [Noise reduction] feature can help to reduce this issue, though it may also negatively affect the resolution of fine detail.

WHITE BALANCE

See the *Shooting with Your D3200* chapter for details.

ISO SENSITIVITY

See the *Shooting with Your D3200* chapter for details.

ACTIVE D-LIGHTING

The item can help optimize the appearance of highlight and shadow areas when shooting a scene with high contrast. It is most effective with Matrix metering. Since its effect is applied during in-camera processing, it is not possible to reverse it when recording JPEG files. The effects can, however, be altered subsequently in NEF (RAW) files. Active D-Lighting cannot be used at an ISO sensitivity of Hi 1.

1. Highlight **[Active D-Lighting]** and select it.
2. Highlight the required option **[On]** / **[Off]** and select it.

AUTO DISTORTION CONTROL

This item controls the degree of adjustment applied to correct for linear distortion in photographs. Typically, wide-angle (short focal length) lenses produce barrel-distortion (straight lines to bow outward from the center of the image), while long focal lengths produce pincushion distortion (straight lines to bend inward to the center of the image).

This feature is only available with D or G-type Nikkor lenses (PC, fisheye, and other certain types of lens are excluded), and does not apply when recording video.

1. Highlight **[Active D-Lighting]** and select it.
2. Highlight the required option **[On]** / **[Off]** and select it.

COLOR SPACE

This item sets the Color Space used by the D3200. Choose sRGB for images that you want to use straight from the camera, for example to post to a website or print. Alternatively, use Adobe RGB for images that will be post-processed before output.

1. Highlight **[Color space]** and select it.
2. Highlight the required option and select it.

NOISE REDUCTION

The **[On]** selection can help reduce the appearance of electronic noise in an image when shooting at protracted exposures times; it takes effect at all ISO sensitivity settings. At exposure times about one second or longer, and/or when the ISO sensitivity setting is high, the processing time for each recorded image will increase by approximately 100% when this feature is active. During this period, "Job nr" will blink in the viewfinder—no other photograph can be recorded at this time. If **[Off]** is selected, noise reduction is still performed at high ISO settings; however, the degree of adjustment is lower compared with when **[On]** is selected.

1. Highlight **[Noise reduction]** and select it.
2. Highlight the required option **[On]** / **[Off]** and select it.

HINT: Noise Reduction affects the resolution of fine detail, so unless absolutely necessary, avoid this option, and apply noise reduction during post-processing using a specific noise reduction tool within an image editing application, or dedicated noise reduction application for more refined control.

AUTOFOCUS-AREA MODE

See the *Shooting with Your D3200* chapter for details.

AF-ASSIST ILLUMINATOR

See the *Shooting with Your D3200* chapter for details.

METERING

See the *Shooting with Your D3200* chapter for details.

MOVIE SETTINGS

See the *Shooting with Your D3200* chapter for details.

FLASH CONTROL FOR BUILT-IN FLASH

See the *Nikon Flash Photography* for details.

The Setup menu is used to establish the basic configuration of the camera.

> This is the first page of the top-level Setup menu screen.

```
                    SETUP MENU
  ▣
  ▣   Reset setup options          --
  ⦿   Format memory card           --
  ⦿   Monitor brightness            0
  ▨   Info display format         info
  ▤   Auto info display           OFF
      Clean image sensor            --
      Lock mirror up for cleaning   --
  ?   Video mode                  PAL
```

RESET SETUP OPTIONS

To restore default settings to the Set up menu:

1. Highlight [Reset setup options] and select it.
2. Highlight [Yes] and select it.

The default settings are as follows:

OPTION	DEFAULT
LCD Brightness	0
Info Display format	Graphic; Background color is White
Auto info display	On
Clean image sensor	Clean at startup & shutdown
HDMI – Output resolution	Auto
HDMI – Device control	On
Flicker reduction	Auto
Time zone & date – Daylight saving time	Off
Auto image rotation	On
Auto timers off	Normal
Self-timer delay	10s
Self timer – Number of shots	1
Beep	Low
Rangefinder	Off
File number sequence	Off
Buttons – Fn	ISO sensitivity
Buttons – AE-L/AF-L	AE/AF lock
Buttons – Shutter release locks autoexposure	Off
Slot empty release lock	Release locked
Print date	Off
GPS – Standby timer	Enable
GPS – Use GPS to set camera clock	Yes
Eye-fi upload	Enable

FORMAT MEMORY CARD

A memory card should always be formatted whenever it is inserted in the camera to reduce the risk of errors when data is written to or read from the card. This is particularly important if you use your memory cards in different camera models. Before you format the card, ensure that any image files stored on it have been saved and backed up.

1. Highlight [Format memory card] and select it.
2. Highlight [Yes] and select it.

MONITOR BRIGHTNESS

The brightness of the LCD monitor can be adjusted to help improve viewing. A negative value reduces screen brightness, while a positive value increases screen brightness; a grayscale is displayed to help assess the effect on tonal range; Highlight [Monitor brightness] and use ▲ and ▼ to adjust the value manually.

INFO DISPLAY FORMAT

The D3200 offers two different styles for the Information Display: [Classic] and [Graphic]. To select a style:

1. Select the [Info display format] item and select it.
2. Highlight the desired option from [Classic] or [Graphic] and select it.
3. The [Classic] and [Graphic] options offer a choice of background color. Highlight one of the options [Blue], [Black] and [Orange] for [Classic] and [Green], [Black] and [Brown] for [Graphic], and select it

I recommend using the [Classic] display because it offers the greatest clarity, although the [Graphic] display may be more helpful to less experienced photographers because it provides a visual representation of the lens aperture and shutter speed. Helpfully, the Information Display is rotated accordingly if the camera is turned to shoot a picture in the vertical format.

AUTO INFO DISPLAY

If [On] is selected, the Information Display will be shown on the monitor once the shutter release button is pressed down halfway. If [Off] is selected, it will be necessary to press either the 🖿 button, or the ⟨⊞⟩ button to view the Information Display. When [Off] is selected at the [Image review] item in the Playback menu, the Information Display will also be shown immediately after an exposure is made.

CLEAN IMAGE SENSOR

This item is used to automatically clean the optical low-pass filter (OLPF) of the D3200 by vibrating it at high frequencies. It is effective in removing loose, dry particles that have settled on the filter surface, but it will not remove smear marks caused by liquids or grease; these will require cleaning with an appropriate fluid and swabs. You may even want to consider having it professionally serviced so as not to damage the sensor.

To configure the self-cleaning feature, highlight the [Clean image sensor] item and select it to display two options: [Clean now] and [Clean at start up/shut down]. [Clean now] is highlighted by default, and pressing the ⊛ button will initiate the process during which the message, "Cleaning image sensor," is displayed on the monitor; this option can be used anytime during camera operation.

HINT: It worth getting into the habit of checking images periodically as you shoot for any telltale particle shadows, by using the zoom function in image Playback by pressing the ⊕ button.

To have the cleaning process commence automatically, highlight the [Clean at startup/shutdown] option and select it to display four options:

○ ⊛ON [Clean at start up]: Cleaning is only performed at startup.

○ ⊛OFF [Clean at shutdown]: Cleaning is only performed at shutdown.

○ ⊛ON/OFF [Clean at start up and shut down] (default): Cleaning is performed at startup and shutdown.

○ [Cleaning off]: Automatic cleaning function is off.

[Clean at startup] would appear to be the most logical selection, as it will help remove any unwanted material before you start shooting. Having the function operate at camera shutdown will bring no benefit to images that have already been recorded and will have no effect on any material that settles on the low-pass filter subsequently, while the camera is dormant; therefore, I can see little advantage in running the process at this point.

NOTE: Using any other camera control or function will interrupt the sensor cleaning process. If the built-in flash is raised and charging, the sensor cleaning process may not operate when the camera starts up.

NOTE: If the sensor cleaning process is repeated several times in rapid succession, the D3200 may disable the function to protect the camera's electrical circuitry. If this occurs, wait a few minutes before attempting to use the function again.

NOTE: When operating the sensor cleaning function, a short sequence of very faint high-pitch squeaks may be heard; this is normal and not an indication of malfunction.

LOCK MIRROR UP FOR CLEANING

Nikon expressly recommends that manual cleaning of the OLPF should be performed at an authorized service center. However, in recognition of the fact that this is likely to be impractical for a variety of reasons, this item enables the reflex mirror to be locked up in its raised position and the shutter opened, to provide access to the front surface of the OLPF.

CAUTION: Nikon states that under no circumstances should you touch or wipe the surface of the OLPF, as it is extremely delicate. Any manual cleaning process you perform is done entirely at your own risk, and any damage caused to the low-pass filter or any other part of your camera as a result of manual cleaning by the user will not be covered by warranties provided by Nikon.

To inspect and/or clean the OLPF, ensure the camera has a fully charged battery installed or is powered by the optional EH-5b AC adapter/EP-5A adapter. Highlight the [Lock mirror up for cleaning] item, and press ▶ to display [Start]. Press ⊗ and a series of dashes are displayed in the control panel, while a dialog box will appear on the monitor with the following instruction: "When shutter button is pressed, the mirror lifts and shutter opens. To lower mirror, turn camera off." When the shutter release is pressed all the way down, the mirror will lift and remain in its raised position, the monitor display and viewfinder will go blank. Keeping the camera facing down, so any debris falls away from the filter, look up into the lens mount to inspect the low-pass filter surface (it is probably helpful to shine a light onto it).

NOTE: The [Lock mirror up for cleaning] item is not available if the battery level is at ▯▰▰ (60%), or less; in this case it will be shown in gray.

NOTE: The photosites on the CMOS sensor of the D3200 are approximately 4.8 microns (mm) square (one micron = 1/1000 of a millimeter); therefore, offending particles are often very, very small, and it is unlikely you will be able to resolve all of them by eye.

To clean the OLPF, keep the camera facing down and use a rubber bulb blower to gently puff air toward the low-pass filter surface. Take care that you do not enter any part of the blower into the camera. Never use an ordinary blower brush with bristles, which can damage the surface of the low-pass filter, or an aerosol-type blower, which might emit propellant agents or cause condensation and leave a residue. Once you have finished cleaning, switch the camera off to return the mirror to its lowered position. If the blower bulb method fails to remove any stubborn material, you should consider having the sensor cleaned professionally.

CAUTION: If power from the installed battery begins to run low while the mirror is locked up for cleaning, the camera will emit an audible warning and the Self-timer lamp will begin to flash, indicating the mirror will be lowered automatically in approximately 2 minutes.

For users with plenty of confidence, there is a range of proprietary sensor cleaning materials that can be used to clean stubborn material from the optical low-pass filter. These include brushes, swabs, and fluids, and they are available from a number of manufacturers. It must be stressed that if you use any such materials or implements, any cleaning action you perform on the OLPF, or on the camera in general, is done entirely at your own risk.

CAUTION: If you decide to clean the low-pass filter in your D3200 with a wet process, make sure you NEVER use any alcohol-based (e.g., ethanol or methanol) cleaning fluid. The low-pass filter has a special antistatic coating that will be damaged by such materials.

Finally, if you have Nikon Capture NX2 software, you can use the [Image Dust Off ref photo] item in the Setup menu with NEF files shot using the D3200 to help remove the effects of dust particles on the low-pass filter by masking their shadows electronically.

VIDEO MODE

The [Video Mode] item allows you to match the camera to the video standard of any external device it is connected to. This option should be set before connecting your camera to the device with an appropriate A/V cord; choose either [NTSC], or [PAL] accordingly.

HDMI

The [HDMI] item allows you to select the output resolution to an HDMI viewing device and can be used to enable remote control of the D3200 from HDMI devices that support the HDMI-CEC (High-Definition Multimedia Interface—Consumer Electronic Control) standard. These options should be set before connecting your camera to the HDMI device with an appropriate HDMI cord.

Use the [Output resolution] item to select the format for images to be output to the HDMI device. If [Auto] is selected, the D3200 will set the appropriate format automatically.

If [On] is selected for the [Device control] item when the D3200 is connected to a device that supports the HDMI-CEC standard and both devices are on, options for [Play] and [Slide show] will be displayed on the HDMI device screen and its remote control can be used in place of the camera's Multi Selector and ⊛ button during playback of full frame images or a slide show. If [Off] is selected for the [Device control] item, the HDMI device's remote control cannot be used to control the D3200 for image display purposes.

FLICKER REDUCTION

The [Flicker reduction] item is intended to help reduce the effects of banding that can occur when using Live View or when recording movies under fluorescent or mercury vapor type lighting. Select [Auto] to have the camera choose the frequency automatically, or choose the frequency that matches that of the local AC power supply. In some situations this item may not be particularly effective, so set the camera to either M or A exposure modes and use a small aperture (large f/number).

TIME ZONE AND DATE

The [Time zone and date] item enables you to set and change the date and time recorded by the camera's internal clock, and how it is displayed. To set the internal clock, highlight the [Time zone and date] item in the Setup menu. Press ▶ to

∧ As long as you have already set the date and time when you first set up your camera, if you travel to a different time zone, simply use the **[Time zone]** feature to tell the camera where you are it will automatically adjust to the correct date and time based on the zone you enter.

display the menu options and to highlight **[Time zone]**. Pressing the Multi Selector to the right displays a map of world time zones. Press either ◀ or ▶ to select the appropriate time zone, and press ⊛ to confirm the selection and return to the **[Time zone and date]** menu.

Highlight the **[Date and time]** option, and select it to display the date/time clock. Select each item in turn, adjusting as needed by using ▲ and ▼ until the full date and time have been entered. Finally press ⊛ to confirm the settings and return to the **[Time zone and date]** menu.

Highlight the **[Date format]** option and select it to display the list of choices. To determine the order in which the date and time are displayed, highlight the desired date format and press ⊛ to confirm the selection.

Finally, highlight the **[Daylight saving time]** option and select it to display two choices; the default setting is **[Off]**. If daylight saving time is in effect in the current time zone, highlight **[On]** and press ⊛ to confirm the selection. To exit the menu system and return the camera to its Shooting mode, press the shutter release button halfway down.

HINT: If you travel to a different time zone, it is only necessary to adjust the **[Time zone]** option; the date and time will be automatically adjusted for the selected time zone. The only other option that may need to be adjusted is the **[Daylight Saving Time]** option.

HINT: The internal clock is not as accurate as many wristwatches or domestic clocks, so it is important to check it regularly.

LANGUAGE

The [Language] item allows you to select one of 28 languages for the camera to use when displaying menus and messages. To select the language, highlight the required option under the [Language] item using ▲ or ▼. Finally, press the ⓞⱪ button to confirm your selection. If you wish to change the language at any time after the initial setup, repeat the procedure just described.

IMAGE COMMENT

This item allows you to attach a short note or reference to an image file. Comments can be up to 36 characters and may contain letters and/or numbers. Since the process requires each character to be input individually, this is not a feature you will use for every picture; however, it is useful as a way of assigning a general comment (i.e., the name of a location/venue/event) or attaching notice of authorship/copyright.

To attach an image comment:

1. Highlight [Image comment] and select it.
2. Highlight [Input comment] and select it—a screen will appear with a keyboard display containing letters and characters.
3. To enter your comment, highlight the character you wish to input by using the Multi-selector button and press ⓞⱪ to select it. If you enter the wrong character, rotate the Command dial to move the cursor over the unwanted character and press the 🗑 button to erase it.
4. Press the ⓞⱪ button to save the comment and return to the [Image comment] options list.
5. To actually attach the comment to your photographs highlight and select [Attach comment]. A small check mark will appear in the box to the left of the option.
6. Finally, highlight [Done] and press the ⓞⱪ button to confirm the selection.

If you wish to exit this process at any time without attaching the comment, simply press the MENU button prior to step 5. When the check mark is present in the [Attach comment] option of the [Image comment] item, the saved comment will be attached to all subsequent images shot on the D3200. To prevent the comment from being attached to an image, simply return to the [Image comment] menu and uncheck the [Attach comment] box by highlighting the option and pressing ▶. The comment will remain stored in the camera's memory and can be attached to future images simply by rechecking the [Attach comment] box. The comment will be displayed on the third page of the photo information display, available via in single image playback. It can also be viewed in Nikon View NX2 or Capture NX2 software.

AUTO IMAGE ROTATION

The D3200 automatically recognizes the orientation of the camera as it records an image: horizontal, vertical rotated 90° clockwise, or vertical rotated 90° counter-clockwise. At its default setting, the camera stores this information, so the image will be automatically rotated during image playback. It will also be displayed in the correct orientation on a computer with compatible software. If you do not want the camera to record the shooting orientation, the [Auto Image Rotation] feature can be switched off.

To set [Auto image rotation]:

1. Highlight the [Auto image rotation] item and select it.
2. Highlight [On] or [Off] as required.
3. Press ⊛ to confirm the selection.

NOTE: [On] must be selected for [Rotate tall] in the Playback menu for the image to be displayed on the monitor in the orientation in which it was taken.

IMAGE DUST OFF REF PHOTO

This item is designed specifically for use with the Image Dust Off function in Nikon Capture NX2. The image file recorded by this function creates a mask that is electronically "overlaid" on a NEF (Raw) file to enable the software to reduce or remove the effects of shadows that are cast by dust particles on the surface of the optical low pass filter. To obtain a reference image for the Dust Off Ref Photo function, you must use a CPU-type lens (Nikon recommends use of a lens with a focal length of 50mm or more). This function can only be used with NEF (Raw) files; it is not available for JPEG files.

To use [Dust Off ref photo]:

1. Highlight the [Dust Off ref photo] option from the Setup menu and select it.
2. [Start] and [Clean sensor and then start] will be displayed on the monitor screen. Highlight [Start] and press ⊛ to begin the process: "rEF' will appear in the viewfinder and the message, "Take photo of bright featureless white object 10cm from lens. Focus will be set to infinity" will be displayed in the monitor screen. If [Clean sensor and then start] is selected and ⊛ is pressed, the camera will vibrate the low-pass filter before displaying the messages just described.
3. Point your camera at a featureless white subject positioned approximately four inches (10 cm) from the front of the lens.
4. Press the shutter release button all the way down (focus will be set automatically to infinity).

Once you have recorded the Image Dust Off reference data file, it can be displayed in the camera during image playback. It appears as a grid pattern with Image Dust Off Data displayed within the image area. A Dust Off reference data file can be identified by its file extension, which is NDF; these files cannot be viewed using a computer.

HINT: This feature is reasonably effective, but the dust particles can be dislodged and shift between shots providing no guarantee that this technique will be completely successful if you save only one reference file. The best approach is to shoot several reference files during the course of a shoot and use the one that was made closest to the time of the exposure you need to correct.

AUTO OFF TIMERS

This sets how long the monitor screen stays on: if no camera functions are performed during menu display and image playback [Playback/menus], while an image is displayed after shooting [Image review], during Live View [Live View]; and how long the standby timer, viewfinder, and information display stay on when no camera function is performed [Standby timer]. The options are: [Short], [Normal], [Long], and [Custom] (the default is [Normal]) The standard times are show in the chart, while the [Custom] option requires a time to be selected and then highlighting [Done] before selecting it.

OPTION	PLAYBACK / MENUS	IMAGE REVIEW	LIVE VIEW	STANDBY TIMER
Short	20 sec	4 sec	5 min	4 sec
Normal	1 min	4 sec	10 min	8 sec
Long	1 min	20 sec	20 min	1 min

HINT: Selections under this item should be considered in respect of the power drain that the LCD screen causes; the general advice here is to set the shortest duration that is convenient.

SELF-TIMER

This item controls the duration of the shutter release delay in the Self-timer mode, and the number of pictures that will be taken when the feature is activated by pressing the shutter release button.

> Here are the options for the [Self-timer] function.

O [Self-timer delay] options: 2 s, 5 s, 10 s, and 20 s.

O [Number of shots]: Select the number of exposures from 1 to 9; at a value other than 1, the exposures will be made at intervals of four seconds.

REMOTE ON DURATION

This item is used to set the duration of the period the camera will ready to receive a signal from the ML-L3 remote release control, when using one of the remote release modes, before restoring the release mode selected previously. I recommend using shorter durations to conserve battery power.

BEEP

Select either [Low] or [High] to have an audible warning sound when the timer is counting down in self-timer and delayed release modes, when the camera attains focus in AF-S (single-servo) autofocus, when focus locks in Live View, or when a photograph is taken in quick-response mode. Select [Off] to cancel any audible warning. No warning will sound in Q Quiet shutter release mode and during video recording.

HINT: This is a matter of personal preference, but the audible warning can be a distraction in many shooting situations. For that reason, I recommend selecting [Off] for this item; ⊛ will be displayed in the control panel to confirm the warning is switched off.

RANGEFINDER

This item is available in all shooting exposure modes except M (Manual). For use when focusing manually, [On] should be selected in order to have the exposure indicator scale assist you by showing whether focus has been acquired, and if not, where the focus point is located. This feature requires that a lens with a maximum aperture of f/5.6, or larger (lower f/number) is used; the function does not operate in Live View or the Movie mode.

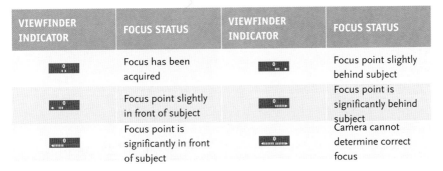

VIEWFINDER INDICATOR	FOCUS STATUS	VIEWFINDER INDICATOR	FOCUS STATUS
	Focus has been acquired		Focus point slightly behind subject
	Focus point slightly in front of subject		Focus point is significantly behind subject
	Focus point is significantly in front of subject		Camera cannot determine correct focus

FILE NUMBER SEQUENCE

Controls whether file numbering continues in a consecutive sequence (1) from the last number used when a memory card is formatted, or (2) when a new folder is created, or (3) when a new memory card is inserted in the camera; or whether to reset to 0001.

[On]: This is the default. Whenever a memory card is formatted, or a new memory card is inserted in the camera file numbering continues, consecutively, from the last number used or the largest number in the current folder, whichever is higher. If the current folder contains a photograph numbered 9999, a new folder will be automatically created, and numbering will be reset to 0001.

[Off]: File numbering is reset to 0001 whenever a memory card is formatted, a new folder is created, or a new memory card is inserted in the camera.

[Reset]: The same as the [On] option, except that the file number is reset to 0001 and a new folder is created when the next picture that is taken.

HINT: If you expect to shoot pictures using more than one memory card, I strongly suggest that you use the [On] option. Otherwise you will potentially end up with duplicate file numbers and names..

BUTTONS

Assigns the role performed by the Function (Fn), AE-I/AF-L, and shutter release buttons. Highlight [Buttons] and select it to display a list of the three options:

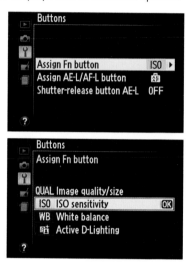

> This shows the options for selecting the button to be assigned a role using the [Buttons] item.

> The Fn button can be assigned one of the four roles shown on this menu page.

[Assign Fn button]: The Function (Fn) button can be assigned a variety of different functions using the [Buttons] > [Assign Fn Button] item.

- O **[Image quality/size]:** Press the Fn button and rotate the Command dial to select the image quality and size.
- O **[ISO sensitivity]:** Press the Fn button and rotate the Command dial to select the ISO sensitivity value.
- O **[White balance]:** Press the Fn button and rotate the Command dial to select the white balance value (only available in P, S, A, and M modes).
- O **[Active D-Lighting]:** Press the Fn button and rotate the Command dial to select the ADL level (only available in P, S, A, and M modes).

[Assign AE-L / AF-L button]: The AE-L/AF-L button can be assigned a variety of different functions using the [Buttons] > [Assign AE-L/AF-L button] item.

- O 🔳 **[AE/AF lock]:** Focus and exposure are locked when the AE-L/AF-L button is pressed.
- O 🔳 **[AE lock only]:** Exposure is locked when the AE-L/AF-L button is pressed.
- O 🔳 **[AF lock only]:** Focus is locked when the AE-L/AF-L button is pressed.
- O 🔳 **[AE lock (hold)]:** Exposure is locked when the AE-L/AF-L button is pressed and remains locked until the button is pressed again or the exposure meter turns off automatically.
- O 🔳 **[AF-ON]:** Autofocus is initiated when the AE-L/AF-L button is pressed. Pressing the shutter release button will not activate autofocus.

NOTE: If [AF-ON] is selected, the Vibration Reduction (VR) feature, available on some Nikkor lenses, will not operate when the AE-L/AF-L button is pressed; VR is only activated by pressing the shutter release button. If you use the technique of locking focus by controlling autofocus operation via the AE-L/AF-L button, when you decide to take a picture press the shutter release button and pause briefly when it is depressed halfway to allow the VR system to activate and settle, before pressing it all the way down to operate the shutter.

[Shutter release button AE-L]: This option determines which buttons can be used to lock the exposure value.

○ [OFF]: Only the AE-L/AF-L button will lock exposure.

○ [ON]: The exposure can be locked by either pressing the AE-L/AF-L button, or pressing the shutter release button down halfway.

HINT: This is a matter of personal preference, but if you wish to recompose the picture after taking a meter reading, having the exposure locked by simply pressing the shutter release button can be convenient.

SLOT EMPTY RELEASE LOCK

This item determines whether or not the shutter will operate without a memory card installed in the camera. If [Release locked] is selected, the shutter release is disabled if no memory card is installed in the camera. If [Enable release] is selected, the shutter release operates if no memory card is installed in the camera. The camera stores no images; however, the last recorded image is displayed in demo mode.

HINT: Disaster potentially looms with this item if it is set to the [Enable release] option—you do not want the camera to operate as though it is recording pictures when in fact there is no memory card installed!

PRINT DATE

This item enables date information to be imprinted within the image area as it is recorded.

OPTION	INFORMATION
Off	No information is imprinted within the image area
Date	Just the date, or the date plus time, are imprinted within the image area.
Date and time	
Date counter	A time stamp is imprinted showing the number of days between the date the image is recorded and a selected date. Up to three different dates can be stored in this option, after a date is selected for the first time; enter a date and press ⊛ to access the [Choose date] and the [Display options] pages.

NOTE: The date information format is the same as for [Time zone and date] item in the Setup menu. This item is not available with NEF raw recording, and cannot be added to or removed from pictures already saved to the memory card.

STORAGE FOLDER

The D3200 uses a folder system to organize images stored on the installed memory card. This allows you to select which folder the images will be saved to, and enables you to create new folders. If you do not use any of the folders options, the camera will automatically create a folder named 100D3200, in which the first 999 pictures recorded by the camera will be stored. If you exceed 999 pictures, the camera will create a new folder, named 101D3200. A new folder will be created for each set of 999 pictures. The three-digit prefix is only displayed when the memory card is connected to a computer, either directly from the camera or via a card reader.

You can create your own folder(s) and name them for your reference. A three-digit number between 100 and 999 always prefixes the folder title; the user can assign a five-character folder name. If you use multiple folders on a single memory card, you must select one "active" folder to which all images will be stored until an alternative folder is chosen.

NOTE: If the folder that has reached full capacity (i.e. 999 images) is folder number 999D3200, the camera will disable the shutter release button and prevent you from making an exposure. You will have to create a new folder with a lower number, or choose another folder on the memory card that still has space for new images. Likewise, the shutter release button will be disabled if the active folder contains a picture numbered 9999.

To create a new folder:
1. Highlight the [Storage folder] item and select it.
2. Highlight the [New] option and select it.
3. Designate the name/number of the new folder by using the keypad of letters and numbers that are displayed on the monitor screen. Use the Multi Selector to select the required character and press ⊛ to input it. To move the cursor, rotate the Command dial.
4. To delete a character at the current cursor position press the 🗑 button.
5. Press ⊕ to confirm the action and return to the Setup menu.
6. Press MENU to exit without creating a new folder name.

To select an existing folder:
1. Highlight the [Storage folder] item and select it.
2. Highlight the [Select folder] option and select it.
3. A list of the folders currently stored on the memory card is displayed; highlight the required folder.
4. Press ⊛ to confirm the action and return to the Setup menu.

The [Rename] option allows an existing folder name to be changed.

The [Delete] option allows all empty folders on the memory card to be deleted.

HINT: Folders may be useful if you expect to take pictures of a variety of subjects (i.e., various different locations on a vacation), but with the relatively low cost of memory cards it is probably easier, and more efficient, to use multiple cards.

HINT: Personally, I believe that using multiple folders to be time consuming, potentially confusing, and fraught with danger! If you have more than one Nikon digital camera and move cards between them, the different cameras will not be able to display images stored in folders created by another camera, unless [All] is selected for [Playback folder]. If the second camera then creates a new folder, it will have a higher prefix number than the folder created by the first camera. Even multiple folders created by the D3200 can present problems in other cameras, as new images will be saved to the currently selected folder with the highest prefix number.

GPS

Using the optional Nikon GP-1 GPS unit connected to the accessory terminal of the D3200, it is possible for the camera to record GPS information when a picture is taken. As soon as the camera confirms communication with the connected GPS device, 🛰 will be displayed in the Information Display. When the 🛰 icon is blinking, it means the GP-1 is still searching for a GPS signal, and any picture taken will not include GPS data. If the 🛰 icon is not displayed, it means the camera has received no new GPS data from the GP-1 for at least 2-seconds; again, no GPS data will be recorded if a picture is taken. To view GPS data, open an image in single-image playback and scroll to the GPS Data page. The options available for [GPS] are as follows:

○ **[Standby timer]:** Allows you to choose whether or not the exposure meters will turn of automatically when a GPS unit is attached. There are two sub-options:

● **[Enable]** (default): This option helps to reduce D3200 battery drain. If no camera operation is performed for the period selected at [Auto off timers] > [Standby timers] in the Setup menu, the exposure meter will turn off automatically. When a GP-1 device is connected, the delay is extended by up to one minute after the exposure meter is activated or the camera turned on to allow time for the camera to acquire GPS data.

● **[Disable]:** The exposure meter will not turn off automatically while the GP-1 device is connected; GPS data will always be recorded.

○ **[Position]:** This item is only available if a GP-1 device is connected and GPS communication is established, when it displays latitude, longitude, altitude, and Coordinated Universal Time (UTC). If GPS communication is not established, the [Position] item is shown grayed out.

○ **[Use GPS to set camera clock]:** Select [Yes] to synchronize the camera clock with the UTC time code reported by the GP-1 device.

EYE-FI UPLOAD

This item is only available when a dedicated Eye-fi memory card is installed in the D3200. The wireless communication-enabled Eye-fi memory cards must be used according to the laws and regulations that apply in the shooting location. To upload image files directly from the camera to the predetermined destination, select [Enabled]. In areas where Wi-Fi is unavailable, or wireless devices are prohibited, ensure the [Disable] option is selected.

FIRMWARE VERSION

Use this item to display the current firmware (A, B & L) installed in the camera. To check the current firmware installed on your camera, highlight the [Firmware version] option from the Setup menu and select it. The details of the firmware are displayed on the next page. Press ⊛ button to return to the Setup menu. Firmware updates can be downloaded from any of the Nikon technical support web sites, visit: www. nikon.com.

☑ THE RETOUCH MENU

The Retouch menu is only available when an installed memory card contains image files. Items in this menu enable images to be cropped, enhanced, and modified before saving them as a separate copy.

> This is the first page of the top-level Retouch menu screen.

```
                    RETOUCH MENU
  ▶
  ◻    D-Lighting                    🔂
  ◻    Red-eye correction            👁
  ⟊    Trim                          ✂
  ◪    Monochrome                    ◱
  🗑    Filter effects               ◐
       Color balance                 ⚙
       Image overlay                 🔁
  ?    NEF (RAW) processing          RAW🔁
```

CREATING A RETOUCH COPY

Creating a retouched copy of an image file does not affect the integrity of the original source file, which is retained on the memory card.

1. Highlight [RETOUCH MENU] and select it.
2. Highlight the required item and select it; if a list of further options is displayed, highlight the required option and select it.
3. Thumbnail images are displayed six at a time; select an image—a yellow frame will show around it. To see an enlarged view, press and hold the ⚲ button. If the image file is marked with a small yellow box containing a cross, the currently selected retouch option cannot be applied.
4. Press ⊛ to display the retouch options (see details below) for each of the menu items. To cancel the process, press MENU.
5. Press the ⊛ button to complete the process; an ☑ icon identifies the retouched copy file.

NOTE: The [RETOUCH MENU] can be accessed directly from full-frame playback by pressing the ⊛ button. To return to full-frame playback, press the ▶ button.

NOTE: Except in the case of [Trim], [Image overlay], [NEF (RAW) processing], and [Resize] the following apply:

o Copies of JPEG images are the same size/quality as the original file.
o Copies of NEF files are saved as [Large] and [Fine] JPEG files.

∧ Red-eye effects are possible when taking a photograph using the D3200's built-in flash or an external Speedlight. If your subject has red-eye, you can employ the [Red-Eye Correction] item in the Retouch menu to fix it in-camera.

⬚ D-LIGHTING

The D-Lighting feature brightens shadow areas to reveal more detail. It is not an overall brightness control; its application is selective. By modifying the tone curve applied to the image, it only affects the shadow areas of the recorded image and preserves the mid-tones and highlights. Use ▲ or ▼ to select the degree of adjustment.

◉ RED-EYE CORRECTION

This feature is only available with pictures taken using either the built-in Speedlight or an external Nikon Speedlight. If you didn't use flash for the selected image, it cannot be retouched with this item and will be marked with a small yellow box containing a cross. If you did use flash but the presence of red eye cannot be detected, a warning message will be displayed.

When red eye is detected, the image is displayed with a small navigation window; press and hold the ⊕ button to zoom into the image. Use the Multi Selector to scroll across the image and confirm the presence of red eye. Press the ⊛ button to cancel the zoom control, and then press ⊛ again to create a modified copy image.

NOTE: The camera may inadvertently select an image not affected by red-eye, which is why it is important to double check the preview image before confirming operation of the red-eye-removal process.

✄ TRIM

This option enables you to crop the original image to exclude unwanted areas.

The selected image is displayed with a yellow frame to show the crop area. Move the crop frame around the image using the Multi Selector. Press the ⚏ button to reduce the size, or use the ⊕ button to increase the size of the crop area. The crop size is displayed in the top-left corner of the image in pixel dimensions (width by height). It is also possible to adjust the aspect ratio of the cropped area; rotating the Command dial allows you to switch between 3:2, 4:3, 5:4, 1:1, and 16:9 (the yellow crop frame will change shape accordingly).

▭▮ MONOCHROME

This item saves the copied image in one of three monochrome effects. The image data is converted to black and white using an algorithm dedicated to this feature; it is a different algorithm than the one used for the [Monochrome] Picture Controls option. The image data for the black-and-white copy is still saved as an RGB file (i.e., it retains its color information). The option has to be selected before the thumbnail images are displayed. The degree of saturation when applying either the [Sepia], or [Cyanotype] effect is adjusted by using ▲ and ▼.

◑ FILTER EFFECTS

This item simulates the effects of various optical lens filters, as follows:
- ○ [Skylight]: This produces a subtle reduction of blue in the image.
- ○ [Warm tone]: A slight amber tint is applied to "warm" colors.
- ○ [Red intensifier]: Reds are intensified.
- ○ [Green intensifier]: Greens are intensified.
- ○ [Blue intensifier]: Blues are intensified.
- ○ [Cross screen]: This item adds a star-point effect to point light sources in the image, which can be controlled via the following:
 - ● [Number of points]: Select from 4, 6, or 8.
 - ● [Filter amount]: Choose the brightness of the light sources affected.
 - ● [Filter angle]: Select the angle of the star points.
 - ● [Length of points]: Select the length of the star points.
 - ● [Confirm]: Preview the effects of the filter. (To preview in full-frame, press the ⊕ button.)
 - ● [Save]: Create the retouched copy.
- ○ [Soft]: This item adds a soft-filter effect.

⚬⚬⚭ COLOR BALANCE

This item is used to produce a copy image with a modified color balance from the original file. Luminance, red, green, and blue histograms, plus a two-dimensional CIE color-space map are displayed next to the thumbnail image. The central point of the color-space map represents the color balance of the original file. Use the Multi Selector to adjust the color balance; the histograms reflect the altered color distribution.

Press the 🔍 button to magnify a section of the preview image (use 🔍 to zoom out); the histograms are updated to represent only the displayed portion of the image. When the preview image is enlarged, press the **AE-L/AF-L** (🔒) button to switch back and forth between the magnifying function and the color-balance control.

🖻 IMAGE OVERLAY

This item enables the combination of two NEF files to form a single image. The source images do not have to be taken in consecutive order, but must have been recorded by a D3200 and be stored on the same memory card.

1. Highlight **[Image overlay]** and select it. Press ▶.
2. The subsequent display will highlight **[Image 1]**. Press the ⊛ button to display thumbnail views of all NEF files stored on the memory card. Highlight a desired image as the first in the overlay. Press the 🔍 button to preview it in full frame.
3. Press ⊛ to place the selected image in **[Image 1]** and **[Preview]** and to return to the overlay display.
4. Highlight the **[Image 2]** box and repeat steps 2 above. Press ⊛ to place the selected image in **[Image 2]** and **[Preview]**.
5. Highlight **[Image 1]** or **[Image 2]** and adjust the blending of the overlay by pressing ▲ or ▼ adjusts the gain value. The effect is displayed in the **[Preview]** image.
6. Highlight the **[Preview]** image by pressing ◀ or ▶.
7. Highlight **[Overlay]** using ▲ or ▼ and press ⊛ to display a preview image.
8. Press the ⊛ button to save the new image, or press 🔍 to return to the previous step.
9. To save the image without displaying a preview, highlight **[Save]** at step 7 above instead of **[Overlay]**, then press the ⊛ button. The new image will be displayed full-frame.

NOTE: Image attributes such as white balance, sharpening, color space, saturation, and hue will be copied from the image selected as **[Image 1]**. The shooting data is also copied from **[Image 1]**.

🖻 NEF (RAW) PROCESSING

This item is used to create JPEG copies of pictures saved at an image quality of NEF (RAW) or NEF (RAW) + JPEG. The following image attributes can be adjusted:

O **[Image quality]**

O **[Image size]**

O **[White balance]**

O **[Exposure compensation]**

O **[Picture Control]**

O **[ISO noise reduction]**

O **[Color space]**

O **[D-Lighting]**

Once all the required adjustments have been made, highlight [EXE] and press ⊛ to complete the process.

🖿 RESIZE

This item is used to create a copy image that has a smaller file size compared with the original image. To do so:

1. Highlight [Resize] and select it. Press ▶.
2. Highlight [Choose size] and select it. Press ▶.
3. Highlight the required size and press ⊛.
4. Highlight [Select image] and choose the desired picture, then press 🔍 to select it, press 🔍 again to deselect the picture; 🖿 appears in the thumbnail image of a selected picture. Press the 🔍 button to preview it in full frame.
6. Repeat as required, then press the ⊛ button.
7. Highlight [Yes] and press the ⊛ button to complete the process.

NOTE: Exposure compensation can be set between ±2EV, while the white balance option is not available with an image created using the [Image overlay] item in the Retouch menu.

🗙 QUICK RETOUCH

This item is used to make a global modification to color saturation and contrast; D-Lighting is applied to increase the brightness of subjects that have dark tones, or subjects that are strongly backlit.

HINT: In terms of image adjustment this is as "quick and dirty" as it gets!

🖿 STRAIGHTEN

Use this item to rotate an image by up to five degrees in steps of approximately a quarter of a degree to correct its alignment. Pressing ▶ to rotate the image clockwise, and press ◀ to rotate counter-clockwise; a grid pattern is displayed to assist aligning the image. When implemented, the edge of the original image is cropped to maintain a rectangular frame shape. Once the required adjustment has been made, press ⊛ to apply it and create a copy picture; the integrity of the original source file is not affected. To cancel the function and return to the playback display, press the ▶ button.

⊙ DISTORTION CONTROL

This item corrects for the effects of optical distortion produced by lenses. The [Auto] option applies correction automatically, which can be refined using the Multi-selector button. The [Auto] option is not available if the [Auto distortion control] item in the Shooting menu is set to [On]. Alternatively, select [Manual] to correct distortion effects manually. Press ◀ to reduce pincushion distortion (straight lines bow inwards to center of frame), and press ▶ to reduce barrel distortion (straight line bow outwards from the center of the frame); the greater the degree of correction,

the more the peripheral area of the original image will be cropped. Once the required adjustment has been made, press ⊛ to apply it and create a copy picture; the integrity of the original source file is not affected. To cancel the function and return to the playback display, press the ▶ button.

▦ FISHEYE

This item modifies an image to emulate the appearance of a picture taken using a fisheye lens; straight lines are not rendered as straight, but with an increasing amount of distortion, so they exhibit a greater degree of bowing outward the further the line is from the center of the frame (barrel distortion). Press ◀ to reduce distortion, and press ▶ to increase distortion; the greater the degree of correction, the more the peripheral area of the original image will be cropped. Once the required adjustment has been made, press ⊛ to apply it and create a copy picture; the integrity of the original source file is not affected. To cancel the function and return to the playback display, press the ▶ button.

▧ COLOR OUTLINE

This item converts a conventional color photograph into an outline image that can be used as a starting point for a drawing or painting. Select the image to be converted and press ⊛ to display a preview of the effect, press ⊛ again to apply it and create a copy picture; the integrity of the original source file is not affected. To cancel the function and return to the playback display, press the ▶ button.

▧ COLOR SKETCH

This item converts a conventional color picture into an image that replicates the appearance of a sketch created with colored pencils. Select the image to be converted and press ⊛ to display a preview of the effect. Highlight [**Vividness**] and use ◀ and ▶ to adjust the degree of color saturation; highlight [**Outlines**] and use ◀ and ▶ to adjust the width of the outline; a thicker outline will make colors appear more saturated. Press and hold the ◹ button to display the preview image in full frame. Press ⊛ to create a copy picture; the integrity of the original source file is not affected. To cancel the function and return to the playback display, press the ▶ button.

▨ PERSPECTIVE CONTROL

Use this menu item to correct the perspective of an image, such as the converging vertical lines that occur when shooting a picture of a tall building with the camera tilted upward to include the entire subject in the frame. Select the image to be converted and press ⊛ to display a preview image overlaid with a grid pattern to assist in assessing the required amount of adjustment; the greater the degree of correction, the more the peripheral area of the original image will be cropped. Once the required adjustment has been made, press ⊛ to apply it and create a copy picture; the integrity of the original source file is not affected. To cancel the function and return to the playback display, press the ▶ button.

🎞 MINIATURE EFFECT

This option replicates the effect of a Nikkor PC-E Tilt/Shift lens. The tilt movement applied with an actual lens alters the focus characteristics by reducing depth of field to a very narrow region, which creates an effect as though the viewer is looking at a model toy of the scene. This menu selection imitates that effect. For best results, shoot pictures to be converted with this item from a high vantage point. Select the image to be converted and press ⊛ to display a preview image; yellow frame lines define the area of the image that will remain in focus. Use the Multi-selector button to position the frame lines and choose the size of the area that will be in focus. Press the ⌕ button to display a preview image. Once the required adjustment has been made, press ⊛ to apply it and create a copy picture; the integrity of the original source file is not affected. To cancel the function and return to the playback display, press the ▶ button.

✎ SELECTIVE COLOR

This item converts a conventional color picture or movie recording to one in which only a limited number of colors/hues are rendered in the retouched copy.

1. Highlight and select [Selective color]. Press ▶.
2. Highlight the desired image and press ⊛. The image will be displayed full-frame with a small yellow square cursor.
3. Press the Multi Selector to position the yellow cursor over a color in the image you wish to select; press AE-L/AF-L button to select it; to assist precision in selecting a color, press ⌕ to enlarge the image and press ⊞ to return to the normal view. (The camera may not detect low-saturated colors.)
4. Rotate the Command dial to highlight the color range value next to the color box. Press ▲ and ▼ to increase or decrease the range of hues; a higher number represents a wider range of hues.
5. Repeat steps 3 and 4 above to select a maximum of three different colors.
6. Press 🗑 to deselect the highlighted color, or press and hold 🗑 to deselect all colors.
7. Press the ⊛ button to complete the action.

▦▶☐ SIDE-BY-SIDE COMPARISON

Use this to compare a retouched copy with the original (source) file. Note that this item is only available if the ⊛ button is pressed to open the [Retouch] menu (it cannot be accessed directly from the [Retouch] menu) when the original source image or its copy is displayed in full-frame playback after pressing the ▶ button. Thumbnail images of the original and retouched copy are displayed next to each other. Use ◀ and ▶ to toggle between, and press ⌕ to view the selected image full frame. If the copy image was created using [Image overlay], use ▲ and ▼ to toggle between the two source images. If multiple copy images of the source image currently selected exist, use ▲ and ▼ to view the other copies.

▦ EDIT MOVIE

This item allows video clips recorded in the Movie mode to be trimmed. You can also use it to save a selected frame from a movie clip as a JPEG photograph. To edit a movie clip length:

1. Press ▶ and scroll using ◀ and ▶ select the required movie clip.
2. Press ⊛ to play the clip; press ▼ to pause it at the required point.
3. Press the **AE-L/AF-L** button to display the editing options.
4. Highlight **[Choose start/end point]** and press ⊛, then highlight either **[Start point]** or **[End point]** and press ⊛.
5. Press ◀ or ▶ to go to the preceding frame or the next frame; rotate the Command dial to skip 10-seconds forward or back. To change the current selection from start point to end point, or vice versa, press the **AE-L/AF-L** button.
6. Once the start point or end point has been selected, press ▲.
7. Highlight the required option and press ⊛. All frames before or after the selected frame, depending on what you have elected, will be cut if **[Save as new file]** or **[Overwrite existing file]** is selected.

To save a selected frame as a JPEG file:

1. Press ▶ and select the required movie clip.
2. Press ⊛ to play the clip; press ▼ to pause it at the required point.
3. Press the **AE-L/AF-L** button to display the editing options.
4. Highlight **[Save selected frame]** and press ▲.
5. Highlight **[Yes]** and press ⊛. The still picture is saved as a Fine quality JPEG.

▤ RECENT SETTINGS

To display **[RECENT SETTINGS]**, press MENU and select the ▤ **[RECENT SETTINGS]** tab. This will display up to a maximum of twenty of the most recently used menu items; as different menu items are selected, they will be added automatically to the top of the recent settings menu list in the chronological order in which they were used. Scroll through these items using ▲ and ▼, and use ⊛ to select the highlighted item. To remove an item from ▤, highlight it and press 🗑 . A confirmation dialog will be displayed; press 🗑 again to delete the item.

RECENT SETTINGS	
Monitor brightness	0
Set Picture Control	⚏SD
D-Lighting	🔲
Trim	✂
Auto off timers	⏱
Clean image sensor	--
Movie settings	--
AF-area mode	--

‹ This is the first page of the top-level Recent Settings menu screen.

Nikon Flash Photography

Before looking at the flash capabilities of the D3200, it is important to understand some basics about the physics of light and flash exposure. One of the key issues affecting flash exposure is the Inverse Square Law. It states that light from a point light source, such as a flash unit, falls off as it travels over a distance by the inverse of the square of that distance. Put simply, if you double the distance from a light source, its intensity drops by a factor of four, because as light travels from the source, it spreads out, illuminating a wider area. So, at double the distance from the source, light covers four times the area. At four times the distance, the light covers sixteen times the area, so its intensity is reduced to one sixteenth of its intensity at the original distance.

Besides being aware of Inverse Square Law, it is also essential to appreciate how exposure of light from a flash unit is influenced by the ISO sensitivity, lens aperture, and shutter speed controls of a camera. Just as when exposing for ambient light, the amount of light required for exposure from a flash occurs in direct proportion to the ISO setting on a camera. So if the ISO value is doubled, the amount of light required from the flash to maintain the same flash exposure level (assuming no other factors change) is halved. Conversely, if the ISO value is halved, the flash output must be doubled to maintain the same flash exposure level. Equally, altering the lens aperture, which controls how much light passes through the camera lens, has the same effect on flash exposure as altering the ISO level. So, for example, if the aperture is changed from f/8 to f/5.6 to allow twice as much light to pass through the lens, the flash need only output half as much light to maintain the same flash exposure level (again, assuming no other factors are altered). If, however, the lens aperture is changed from f/8 to f/11 to allow only half as much light to pass through the lens, the flash output must be doubled to maintain the same flash exposure level.

The intensity of the light produced by an electronic flash unit is always the same; therefore, the flash exposure is controlled by the duration of the flash output. At its maximum output of light, the duration of flash pulse from a modern Nikon Speedlight flash unit is typically about 1/1000 second, so in order to output a reduced amount of illumination, the duration of the flash pulse must be even briefer. Yet, on the D3200, the maximum (fastest) shutter speed at which the opening and closing of the shutter allows the light from the flash to be recorded fully is a 1/200 second. (This maximum speed is known as synchronization speed, or simply "sync.") Therefore, assuming that flash is the only source of light, and provided the shutter speed is set to the maximum sync speed or slower (longer), the shutter speed has no effect on the flash exposure.

The only time the shutter speed is of any consequence when shooting with flash is if ambient light is also being recorded as part of the overall exposure, for example, when using flash as a fill-light (supplementary light) with ambient light, and TTL flash exposure control is selected (in Manual flash exposure control, the shutter speed has no effect on the flash exposure). In this case, the ambient light exposure will be influenced by the shutter speed, which in turn, will affect the flash output level.

Because a flash unit emits a precise, fixed amount of light based principally on the flash-to-subject distance, ISO setting, and lens aperture, the light from the flash will only illuminate the subject properly at a specific distance. Therefore, any element in the scene closer to the flash than the subject (for which the flash output has been calculated either automatically by the camera or manually by the photographer) will be overexposed and anything farther away will be underexposed. The degree of over- or underexposure will depend on how much closer or farther away the element is in relation to the flash unit, since the intensity of the light will be determined by the effect of the Inverse Square Law described previously.

> Here, the D3200 is pictured with the SB-400 flash. This compact unit has a flash head that can be tilted for bounce flash.

Finally, the output of an electronic flash unit, often referred to as its power, is quantified by a value known as its guide number (GN). The higher the guide number, the more powerful the flash unit. Guide numbers are quoted as a distance (usually expressed in either feet or meters) for a given ISO level and angle of view (usually expressed as a lens focal length for the camera format in use). For example, the built-in Speedlight of the D320 has GN of 39 feet (12 m) at ISO 100 (43 feet / 13 m

∧ When you shoot under controlled conditions (such as a studio) with a fixed distance between the subject and flash, manual flash exposure control offers consistent and repeatable results.

with manual flash), and provides coverage for a 18mm lens. It is essential when comparing guide numbers to make sure that the same units are used for linear measurement, ISO value, and focal length.

THE NIKON CREATIVE LIGHTING SYSTEM

Modern electronic flash systems have moved far beyond the fundamental principles of flash exposure control, to incorporate a range of features that refine the process even further. The most advanced of these is the Nikon Creative Lighting System (CLS), which represents the most sophisticated method of flash exposure control developed by Nikon to date. It encompasses a range of attributes that are as much a part of the camera models that support the CLS as of the CLS-compatible Speedlight flash units themselves.

Features include: intelligent through-the-lens (i-TTL) flash exposure control, the Advanced Wireless Lighting (AWL) system that provides wireless control of multiple Speedlights using i-TTL, Flash Value (FV) Lock, Flash Color Information Communication, Auto FP High-Speed Sync, and Wide-Area AF-Assist to improve autofocus accuracy with cameras that have multiple AF points covering a large part of the frame area.

The D3200 is fully compatible with the following external Nikon Speedlights: SB-910, SB-900, SB-800, SB-700, SB-600, SB-400, and SB-R200; however, the camera does not support the Auto FP High-Speed Sync, and FV Lock features. Furthermore, its built-in Speedlight does not support remote control of compatible Speedlights using the AWL system.

When used in combination with a CPU-type lens, the D3200 supports two methods of TTL-controlled flash exposure with either its built-in flash unit or a compatible external Speedlight. To select TTL flash control for the built-in Speedlight, open the Shooting menu and navigate to [Flash cntrl for built-in flash] and press ▶. Highlight [TTL] and press ⓞⓚ. When using an external Speedlight, the flash mode is selected via the (MODE) button on the Speedlight.

[TTL BL] **i-TTL Balanced Fill-Flash:** When the D3200 is set to 3D Color Matrix metering, a D- or G-type Nikkor lens is used, and either the built-in flash is on or a compatible external Speedlight is attached and powered on, i-TTL Balanced Fill-Flash will attempt to balance the exposure of the subject between the prevailing ambient light and the light output from the flash. (i-TTL Balanced Fill-Flash is the default TTL flash mode for the D3200's built-in Speedlight and the SB-700).

NOTE: The discussion of the various flash exposure modes and control options in this chapter assume the camera is set to the P, S, A, or M exposure mode, as the operation of flash in any other exposure mode is fully automated, and the user has no control over selection of flash mode, and cannot set flash compensation.

It is important to understand that whenever the D3200 is used in any of its automated exposure modes (P, S, or A), and TTL flash exposure control is selected ([TTL] is displayed on the camera, while [TTL-BL] is displayed on a compatible external Speedlight), the exposure for both the ambient light and light from the flash is calculated in a fully automated process. The proportions in which the two light sources are used to illuminate the subject will depend on a wide variety of factors including: ISO sensitivity, exposure mode, exposure compensation value, flash compensation level, brightness of both the ambient and flash illumination, the nature of the scene being photographed, plus additional information from the lens (focal length, aperture, and focus distance). The [TTL-BL] mode is the only mode in which the camera's TTL metering system for ambient light and its TTL system for flash exposure control are combined, with the latter receiving information from the former along with focus information from the lens when a D- or G-type lens is used.

Fill-flash is a specific lighting technique in which the flash is used to supplement the main ambient light source, typically in a situation where the subject is not as bright as the background. For example, outdoors on a bright day when the sun is behind the subject, or the subject is set against a bright sky, or indoors when the subject is positioned in front of a doorway or window and the light outside is very bright. The level of illumination provided by the flash should, generally, be weaker than the ambient light, because its purpose is to provide a small amount of additional light in the shadows areas of the subject to help reduce the overall level of contrast across the scene.

NOTE: When shooting portraits of people, animals, and birds, many photographers also use the fill-flash technique to create a small catch light in the eyes of the subject.

When the camera is in Manual exposure mode (M), the exposure for the ambient light is under the complete control of the photographer. The flash exposure, on the other hand, is still handled automatically by the camera's TTL flash exposure control system. Yet, when the D3200 is used in any of its automated exposure modes (P, S, or A), the camera is in complete control of the exposure for both the ambient light and the flash. In all cameras released since 2007, Nikon has modified the strategy used by the [TTL-BL] flash exposure control mode. These cameras, including the D3200, no longer try to balance the flash exposure to the exposure for the ambient light on the background, but place a greater independence on lighting the subject properly. The flash output level and the ambient light are assessed in an attempt to create a balanced exposure between the two light sources at the subject, while less emphasis is placed on the exposure level for the ambient light illuminating the background.

To achieve this, the D3200 will often adjust the exposure for either the ambient light or the flash output, and sometimes both, with the result that, generally, the flash emits less light compared with setting the flash manually for a proper flash exposure for the flash-to-subject distance. Even so, sometimes, particularly when the ambient light is very bright, if left to its own devices, i-TTL Balanced Fill-flash [TTL-BL] can place too much emphasis on the flash-lit portion of the exposure. This results in the subject being over-lit, thereby spoiling the fill-flash effect by making the use of flash appear obvious and the subject appear rather unnatural.

To compound the problem, if you then attempt to compensate by adjusting either the level of the ambient light exposure by using exposure compensation, or the level of flash exposure by using flash compensation, the camera will frequently override or even ignore the level of compensation you choose, because i-TTL Balanced Fill-flash [TTL-BL] is a completely automated process, which makes it difficult to achieve consistent, repeatable results.

i-TTL Standard Flash: This flash mode can be selected as the TTL flash exposure control mode for the D3200's built-in Speedlight, the SB-700, and the SB-400 by setting the camera to Spot metering, or by pressing the (MODE) button on an external Speedlight (SB-910, SB-900, SB-800, and SB-600) so that [TTL] is displayed in its LCD control panel. This mode differs from the i-TTL Balanced Fill-Flash [TTL-BL] mode in that the measurement of ambient light by the camera's TTL metering system is wholly independent of its TTL system for flash exposure control; the two metering systems are not integrated in any way.

So, if you want to achieve consistent, repeatable results when using flash as the main light plus have control over the flash output level and the ambient exposure, or you want to use the fill-flash technique, I recommend you use i-TTL Standard flash [TTL] in combination with Manual exposure mode. In [TTL] flash exposure control, any flash compensation that you set will be honored and applied without the influence of any automated control exercised by the camera. Meanwhile, you can adjust the exposure level for the ambient light at will in Manual exposure mode, since you are in total control of the shutter speed and lens aperture.

However, things become a bit more complicated if you combine [TTL] flash exposure control with any of the three automated exposure modes (P, S, or A), because the only way to adjust the level of exposure for the ambient light in these

exposure modes is to apply exposure compensation, which also affects the flash output level in direct proportion to the amount of adjustment that is applied to the ambient light exposure. For example, with the camera set to A (Aperture Priority) exposure mode, if you apply an exposure compensation of -1 EV to reduce the ambient light exposure level, the flash output will also be reduced by 1 EV.

NOTE: The action of setting the D3200 to spot metering will override the selection of i-TTL Balanced Fill-flash [TTL-BL] mode on an external Speedlight and set the TTL flash mode to i-TTL Standard flash [TTL].

> The D3200 with the SB-700; this unit offers a high degree of sophistication for flash photography, including the ability to control remote flash units wirelessly.

USING I-TTL FLASH EXPOSURE CONTROL

Currently, the SB-910, SB-900, SB-800, SB-700, SB-600, SB-400, and SB-R200 are the only external Speedlights that support i-TTL. If any other external Nikon Speedlight is attached to the D3200, no form of TTL flash exposure control is supported; this applies to all earlier Speedlights, even DX-type Speedlights such as the SB-80DX, designed for earlier Nikon DSLR cameras. Furthermore, the D3200, when used in conjunction with the SB-910, SB-900, SB-800, SB-700, or SU-800 Wireless Speedlight Commander unit, can perform i-TTL flash exposure control as part of a wireless lighting system.

Of the two flash-exposure control modes described above, [TTL-BL] offers the most sophisticated method of automatic flash exposure control. It is not foolproof, however, and in certain shooting conditions, particularly when using flash indoors where the subject is brighter than the background, use of [TTL] is often more reliable and effective.

The following section describes in detail the functionality of the two i-TTL flash exposure control modes and highlights the principal differences between them

when using a single Speedlight unit attached directly to the camera or connected via one of the Nikon dedicated TTL flash cables (SC-17, SC-28, or SC-29). First and foremost, the following are the key features of the i-TTL system in general:

○ It uses fewer monitor pre-flashes than previous Nikon TTL flash control systems. However, they have a higher intensity, which improves the efficiency of obtaining a measurement from the TTL flash control sensor. Also, because it uses fewer pre-flashes, the amount of time taken to perform the assessment is reduced, which enables the camera to perform this process before lifting the reflex mirror.

○ By emitting the monitor pre-flashes before the reflex mirror is lifted, the D3200 can use its 420-pixel RGB metering sensor (located in the prism head of the camera) for TTL exposure control of both the ambient light and the flash, although the camera uses a separate metering protocol for each type of light and for each of the two TTL flash exposure control modes.

○ The D3200's i-TTL system is designed to work with ISO sensitivities between 100 and 6400; Nikon states that at as setting of Hi 1, flash exposure control may be less accurate.

OPERATION OF i-TTL BALANCED FILL-FLASH

The following is a summary of the steps taken by the D3200 when it is set to 3D Color Matrix metering in one of the automated exposure modes (P, S, or A), when the [TTL-BL] flash exposure control mode is used with either the built-in Speedlight or an external CLS Speedlight and a D- or G-type Nikkor lens (i.e., the utmost and most sophisticated automation available with the D3200):

1. At the point where the shutter release button is pressed down halfway, the TTL metering system for the ambient light is activated and meters the overall scene, while the AF system acquires focus and the focus distance from the D- or G-type lens is reported to the camera.

2. Focus distance information and information from the camera's TTL metering system are communicated to the TTL flash exposure control system—this is the only integration of the two TTL metering systems. The focus distance information is only used when an external Speedlight's flash head is in its normal straight-ahead position. If the flash head is tilted or swung from its normal position, the TTL flash exposure control system does not use the focus distance information.

3. When the shutter release button is pressed down fully, the camera sends a signal to the Speedlight to initiate the pre-flash system, which then emits the monitor pre-flashes.

4. The light from these pre-flashes is bounced back through the lens and onto the camera's RGB metering sensor via the reflex mirror, where the TTL flash exposure control system analyzes the intensity of the reflected light.

5. The data from the pre-flash assessment is combined with the focus distance information and ambient light exposure information from the camera's TTL metering system. The TTL flash exposure control system then determines the amount of light required from the Speedlight to balance the flash exposure and ambient light at the subject, and then sets the duration of the flash output accordingly.

6. The reflex mirror lifts up out of the light path and the shutter opens.

7. The camera sends a signal to the Speedlight(s) to initiate the main flash output, which is quenched the instant the amount of light determined in Step 5 has been emitted.

8. The shutter closes the instant the shutter speed duration has elapsed, and the reflex mirror is lowered to its normal position.

> The red shading indicates the approximate area of the flash-metering pattern used for i-TTL Balanced Fill-Flash. The most accurate results will be achieved when the subject is positioned at or close to the center of the frame.

As far as the ambient exposure control is concerned, the camera will set the shutter speed and/or aperture automatically, according to the selected exposure mode, as if there were no flash connected to the camera. However, the use of the flash will impose restrictions on the range of available shutter speeds, dependent upon the selected exposure mode. The flash does not communicate any information to the camera about the calculated flash output level. The camera's TTL metering system and the TTL flash exposure control system do not communicate other than when the camera sends the information from its TTL metering system to the TTL flash exposure control system, along with the focus distance information, as described in Step 2 above.

If you use Manual exposure mode, the TTL flash exposure control system is not told the shutter speed and aperture values; it simply assumes these have been set, so the analog exposure scale is centered on its '0' point. It receives information from the TTL metering system concerning the ambient light and uses this as the brightness of the subject to then set the flash output level accordingly, based on the aperture value, ISO setting, and focus distance.

NOTE: It is possible to use Center-Weighted metering with [TTL-BL], but results are less consistent.

NOTE: The [TTL-BL] flash exposure control mode works best when you want to use the flash as a fill (supplementary) light in conditions where the background is brighter than the subject. This is because the subject can only be brightened by the use of the flash and, when the head of an external Speedlight is in its straight-ahead position, the TTL flash exposure control system will use the focus distance information from the D or G-type lens, which will improve the accuracy of the flash exposure.

NOTE: Despite the refinements to the [TTL-BL] flash exposure control mode, if the subject is as bright as or brighter than the background, more reliable results are often achieved in the [TTL] mode.

NOTE: The integration of the focus distance information when the Speedlight is used in [TTL-BL] flash exposure control mode (with its flash head in the normal straight-ahead position) means that if the flash is used remotely from the camera via one of the dedicated Nikon TTL cables (SC-28, or SC-29), it is essential that the flash is kept at approximately the same distance from the subject as the camera, to ensure flash exposure accuracy.

∧ i-TTL Standard flash is the best option when using the fill-flash technique, as it enables precise control of the flash output level. Here, flash output compensation was set to -2.0 EV, so the flash provided just a small amount of additional illumination to create a catchlight in the subject's eye and light the shadow areas.

NOTE: The main issue with the **[TTL-BL]** mode is that, when left to its own devices, it often produces a result where the subject and background either have an equal brightness, or the subject appears brighter than the background, which looks false. The fill-flash technique, however, is most effective when its use is subtle to the point that it is not obvious that flash was used. Consequently, consider applying a small amount of negative flash compensation, so the flash acts as a proper fill-light to just lift the shadow values of the subject.

OPERATION OF i-TTL STANDARD FLASH

The following is a summary of the steps taken by the D3200 when it is set to 3D Color Matrix metering in one of the automated exposure modes (P, S, or A), when the **[TTL]** flash exposure control mode is used with either the built-in Speedlight or an external CLS Speedlight and a D- or G-type Nikkor lens (i.e., the utmost and most sophisticated automation available with the D3200):

1. At the point where the shutter release button is pressed down halfway, the TTL metering system for the ambient light is activated and meters the overall scene while the AF system acquires focus, and the focus distance from the D- or G-type lens is reported to the camera.

2. Information from the camera's TTL metering system and the focus distance information are used to determine the exposure level for the ambient light; there is no integration of the information from the camera's TTL metering system with the TTL flash exposure control system. The two systems are treated as being wholly independent.

3. When the shutter release button is pressed down fully, the camera sends a signal to the Speedlight to initiate the pre-flash system, which then emits the monitor pre-flashes.

4. The light from these pre-flashes is bounced back through the lens and onto the RGB metering sensor via the reflex mirror, where the TTL flash exposure control system analyzes the reflected light using a center-weighted metering pattern, regardless of the metering pattern selected on the camera. Consequently, a subject at the middle of the frame will have far more influence on the TTL flash exposure control system compared with a subject close to or at the edge of the frame.

5. In the [TTL] mode, the flash exposure control system takes no account of the focus distance information. It is only the light reflected back from the pre-flashes, as "seen" by the center-weighted flash metering pattern that determines the flash output level.

6. The reflex mirror lifts up out of the light path, and the shutter opens.

7. The camera sends a signal to the Speedlight(s) to initiate the main flash discharge, which is quenched the instant the amount of light pre-determined in Step 5 has been emitted.

8. The shutter closes the instant the shutter speed duration has elapsed, and the reflex mirror is lowered to its normal position.

> The red shading indicates the approximate area of the flash-metering pattern used for i-TTL Standard Flash; the greatest accuracy is achieved when the subject is positioned at center of the frame.

As far as the ambient exposure control is concerned, the camera will set the shutter speed and/or aperture automatically, according to the selected exposure mode, as if there were no flash connected to the camera. However, the use of the flash will impose restrictions on the range of available shutter speeds, dependent upon the selected exposure mode.

The independence of ambient light and flash metering from one another in the [TTL] flash exposure control mode creates two potential problems, regardless of the exposure mode selected on the camera. First, if the ambient light level is sufficiently bright for the camera to achieve a proper exposure without flash, then any additional light from the flash will cause the subject to be overexposed. While the metering system for ambient light still does not take into account the amount of light the flash will add to the exposure, as it does in the [TTL-BL] mode, the camera will reduce the ambient light exposure when using the automated exposure modes (P, S, and A), especially in bright conditions, as soon as it detects that a compatible flash unit is connected and turned on (the exposure level for the ambient light is not influenced by the camera when using Manual exposure mode).

For example, in Aperture-Priority mode when the flash is turned on, the shutter speed is increased (how much depends on the brightness of the ambient light). This reduction of ambient exposure prevents the subject from being overexposed, but this regime has a drawback: The background, which is lit by the ambient light, will be rendered darker. For this reason, you may consider not using the [TTL] flash exposure control mode outdoors for fill-flash (especially in bright conditions) while

shooting in the automated exposure modes. The most reliable way to shoot fill-flash with the [TTL] mode is to set the camera to Manual exposure (so you have control over the shutter speed and aperture), and then control the flash using flash compensation.

The second potential problem arises from the highly central emphasis of the metering pattern that the [TTL] flash exposure control mode uses. This pattern is used regardless of the metering pattern selected on the camera for measuring the ambient light. This means that, for the flash metering to be accurate, the subject must be at the center of the frame, occupy an area at least equal to the default size of the camera's Center-Weighted metering pattern, and be a midtone. Furthermore, no account is taken of focus distance information when calculating the flash exposure, and the flash metering sensitivity decreases the farther the subject is placed from the center of the frame.

So, if the subject is significantly off center, the flash metering system will set the flash output to illuminate what it "sees" at the center of the frame, based its assessment of the light from the pre-flashes reflected back from this area of the scene, which can frequently be the background! Consequently, the flash exposure at the subject is not accurate.

NOTE: If Spot metering is selected on the D3200, the flash exposure control mode will always default to [TTL] mode when using either the built-in Speedlight unit or an external Speedlight, regardless of the i-TTL flash mode selected.

NON-TTL AUTOMATIC FLASH WITH SB-800, SB-900 & SB910

So far we have looked at the TTL flash modes, where the D3200 performs all the necessary calculations to set and adjust (if necessary) the flash output level. In these modes, when the shutter release button is pressed to take a picture with flash, the Speedlight is controlled by the camera and reacts to its signals when to start and stop firing.

When using the SB-800, SB-900 and SB-910 external Speedlights with the D3200, there are two additional non-TTL automatic flash modes available, which differ in that the flash carries out the flash exposure calculation, plus the camera is not involved in deciding when to shut off the flash. The flash units have a thyristor circuit that measures the light reflected from the subject through a small window located in the front panel of the main body of the Speedlight. The light output from the flash is measured by its internal circuitry and, once it has accumulated to a certain amount, the thyristor circuit shuts the flash output off. The following two modes are selected on the Speedlight via its Mode button.

AA **Auto Aperture:** The Auto Aperture flash mode, which is indicated in the control panel LCD by AA, can be used in (A) Aperture-Priority, (P) Programmed-Auto, and (M) Manual exposure modes. In this flash mode, the SB-910, SB-900 and SB-800 read the lens aperture, ISO sensitivity setting and, the "command to fire the flash" signal from the camera automatically. Therefore, if the lens aperture is adjusted, the Speedlight will adjust its output accordingly. On the SB-800, and at the default

setting on the SB-910 and SB-900, a monitor pre-flash is emitted prior to the shutter opening to help improve the accuracy of the flash exposure (in particular to prevent overexposure of highlights) by assessing the reflectivity of the scene. The pre-flash light is detected by the thyristor circuitry of the Speedlight's internal sensor, and it uses this to determine the amount of light output required for the flash exposure. In the AA mode, flash does not monitor the main flash pulse, only the pre-flash light.

NOTE: If you want to eliminate the use of pre-flashes in AA mode on the SB-800 when the flash is mounted in the accessory shoe of the camera or connected via a dedicated TTL flash cable, put the Speedlight into SU-4 mode via its Custom Settings menu. In this configuration, the flash monitors the main flash output using its thyristor circuitry. The SB-910 and SB-900 allows pre-flash operation to be specifically canceled via its Custom Settings menu.

A **Automatic:** The Automatic flash mode, which is indicated in the control panel LCD by A, is the other automatic, non-TTL flash mode available with the SB-800 and SB-900 Speedlights. It is not the default option, and it must be selected via the Speedlight's Custom Settings menu. This mode can be used in Aperture-Priority (A) or Manual (M) exposure mode.

In this flash mode, the SB-910, SB-900 and SB-800 read the ISO sensitivity setting and the signal to fire the flash from the camera automatically. However, the lens aperture value must be set manually on the Speedlight to ensure that the subject is within the flash shooting range and can therefore be exposed properly by the flash. This independence between the Speedlight and the camera in respect of the aperture setting means that this mode makes it easy to use the lens aperture to control the balance between the ambient light and flash exposures. The SB-910 and SB-900 offers the option, via its Custom Settings menu item [Non-TTL Auto Flash Mode], to either fire a monitor pre-flash or cancel monitor pre-flash. The SB-800 does not fire any monitor pre-flashes in this mode.

As with the AA mode, it is the thyristor circuitry in the Speedlight that measures either the pre-flash output or the main flash pulse, so the light output from the Speedlight is shut off the instant it has accumulated to the amount the sensor determines will produce a proper flash exposure.

NOTE: The problem with the AA and A modes is that the coverage of the built-in sensor on the Speedlight does not necessarily match the field of view of the lens; therefore it does not "see" the same scene, which can lead to inaccuracies in flash exposure. Furthermore, the flash output is calculated on the assumption that the subject has a mid-tone reflectivity. Therefore, just as with the TTL modes, the flash output will be too high if the subject is very dark-toned and too low when the subject is very light-toned. Flash compensation will need to be set to adjust the flash exposure accordingly.

NOTE: The default setting for the SB-800, SB900 and SB-910 is Auto Aperture flash, but this can be changed to Automatic flash via the Speedlight's Custom Settings menu.

NOTE: Many older Nikon Speedlights and third-party flash units also support the Automatic flash mode with the D3200, since there is no communication between the camera and the flash other than the signal to trigger the firing of the flash unit. However, it will be necessary to enter the ISO and lens aperture values on the flash unit.

MANUAL FLASH EXPOSURE CONTROL

The TTL and non-TTL automatic flash modes all use some degree of automation to control the flash output from either the camera or the Speedlight. However, in the manual flash mode (which is available with all the CLS Nikon Speedlights, most older Nikon Speedlights, and many third-party flash units), you are in complete control of the flash output level.

M **Manual Flash:** To select Manual flash control for the built-in Speedlight on the D3200, open the Shooting menu and navigate to [Flash cntrl for built-in flash] and press ⓞ. Highlight [Manual] and press ⓞ. When using an external Speedlight, with the exception of the SB-400, the flash mode is selected via the MODE button on the Speedlight; the flash mode for the SB-400 is selected from the camera via the [Flash cntrl for built-in flash] item in the Shooting menu. Manual flash mode can be used in Aperture-Priority (A) or Manual (M) exposure mode.

In Manual flash mode, you set the output of the Speedlight (either built-in or external) to a fixed level. It is necessary to calculate the correct lens aperture using the flash-to-subject distance and the guide number (GN) of the Speedlight. For example, at the camera's base sensitivity of ISO 100, the D3200's built-in Speedlight has a guide number (GN) of 43 ft (13 m).

The output level of the built-in Speedlight is determined via [Flash cntrl for built-in flash] > [Manual], where a value between 1/1 (full output) and 1/32 can be selected. Since there is only one specific exposure level for any given sensitivity (ISO) at a particular flash-to-subject distance, it is necessary to calculate the lens aperture required to record a proper exposure. Use the following equation: Aperture = GN / Distance, or alternatively: Distance = GN / Aperture.

Therefore, with the D3200's built-in Speedlight set to 1/1 (full output) at a flash-to-subject distance of 7.5 feet (2.2 m) and an ISO of 100, the lens aperture required to obtain a correct exposure of the subject will be around f/5.6. Similar calculations will have to be performed when using an external Speedlight in Manual flash mode. Always check the guide number (GN) for the particular Speedlight model in use and the focal length set on its zoom head (when applicable), plus the unit of measurement in which the GN is expressed. It will also be necessary to check that the GN you use is for the ISO value set on the camera and the selected flash output level. All Nikon Speedlight manuals contain comprehensive GN charts, and the same information is available online from Nikon technical support websites.

The Manual flash mode is more cumbersome compared with the automation of TTL or even the non-TTL automatic flash modes. However, once the necessary calculations have been performed, the flash output will provide the precise amount of light needed for the subject. Manual flash mode also has the benefit of ensuring the flash emits exactly the same amount of light each time it is fired, so for shooting

situations where all the conditions are constant, it makes achieving consistent, repeatable results very easy. Of course as soon as one of the variables changes (the flash-to-subject distance or the flash zoom head position, for example) it will be necessary to recalculate the flash output level.

GN **Distance Priority Manual Flash:** This mode, which is only available with the SB-910, SB-900, SB-800, and SB-700 Speedlights, provides a variation on the basic manual flash output control by adjusting the flash output according to the lens aperture setting. It requires you to enter a specific flash-to-subject distance of 1 – 66 feet (0.3 – 20 m) and calculate the aperture value for that distance based on the appropriate GN and ISO (as described in the previous section) before setting the aperture on the camera. However, if the aperture value is altered subsequently, the flash output is adjusted automatically to maintain the same exposure level (the flash-to-subject distance must remain unchanged). The flash output can be adjusted if required by using flash compensation. Distance Priority Manual flash mode can be used in Aperture-Priority (A), or Manual (M) exposure mode.

NOTE: The quoted frame rates are based on the camera being set to continuous-servo AF, M or S exposure mode, and a shutter speed of 1/250 second or faster. The buffer capacity, other auto exposure modes, and single-servo AF (particularly in low-light) can, and often will, reduce the frame rate significantly.

NOTE: Using the SB-910, SB-900, or SB-800, the aperture value must be set from the camera or lens, as it is not possible to adjust it from the Speedlight. The SB-700 does not display an aperture value in its LCD control panel.

USING EXTERNAL NIKON SPEEDLIGHTS

The D3200 offers full i-TTL flash exposure control with seven external Nikon Speedlight flash units, which are all compatible with the CLS:

- SB-R200 with GN of 33 feet (10 m) at ISO 100.
- SB-400 with a GN of 69 feet (21 m) at ISO 100.
- SB-600 with a GN of 98 feet (30 m) at ISO 100 with the flash head set to 35mm.
- SB-700* with a GN of 92 feet (28 m) at ISO 100 with the flash head set to 35mm.
- SB-800 with a GN of 125 feet (38 m) at ISO 100 with the flash head set to 35mm.
- SB-900* with a GN of 111 feet (34 m) at ISO 100 with the flash head set to 35mm.
- SB-910* with a GN of 111 feet (34 m) at ISO 100 with the flash head set to 35mm.

* with Standard light distribution selected

All models can be attached to the camera either directly or via dedicated Nikon TTL remote flash cords (SC-28, SC-29, or the discontinued SC-17), with the exception of the SB-R200. It can only be controlled as part of the Nikon Advanced Wireless Control (AWL) flash system via, either the SU-800 commander unit, or the SB-700, SB-800, SB900, or SB-910 Speedlight (used as a master flash unit).

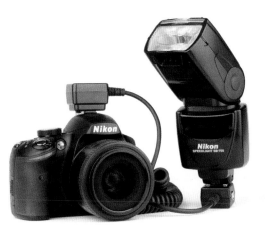

< The optional external Speedlights can be mounted in the accessory shoe on top of the D3200 or connected to it using a dedicated TTL cord, such as the SC-28. Here, the D3200 is shown with the SB-700.

The six Speedlights that can be attached to the D3200's accessory shoe offer further versatility since their flash heads can be tilted and, in the case of the SB-600, SB-700, SB-800, SB-900, and SB-910, swiveled for bounce flash. Unlike earlier Nikon Speedlights, which canceled monitor pre-flashes if the flash head was tilted or swiveled, the SB-400, SB-600, SB-700, SB-800, SB-900 and SB-910 emit pre-flashes regardless of the flash-head orientation. The five latter units also have an adjustable auto zoom head (SB-600: 24–85mm, SB-700: 24-120mm, SB-800: 24–105mm, SB-900/SB-910: 17–200mm FX format, and 12–200mm DX format) that controls the angle of coverage. The SB-700, SB-800, SB-900 and SB-910 also have an accessory diffusion dome to allow them to produce even illumination over a wider field of view. With the diffusion dome, the SB-800 can cover focal lengths as short as 14mm, while the SB-700, SB-900 and SB-910 can cover the field of view of a focal length as short as 8mm on the DX format.

NOTE: If the SB-400 is attached to the D3200 and turned on, [Flash cntrl for built-in flash] changes to [Optional flash], which allows the flash control mode of the SB-400 to be chosen from either TTL or Manual.

HINT: The coverage of the SB-600 and SB-800 is set to correspond to the field of view based on the FX-format (24 x 36mm). Consequently, the narrower angle of view of the DX-format sensor used in the D3200 will restrict the potential shooting range and squander flash power (the SB-700, SB-900, and SB-910 automatically adjust coverage to match the DX format). In this situation, use the following table and adjust the zoom-head position manually to maximize the efficiency of the flash output:

FOCAL LENGTH OF LENS (MM)	ZOOM HEAD POSITION (MM)
14	20
18	24
20	28
24	35
28	50
35	50
50	70
70	85
85	105*

* Available on SB-800 only.

The following chart illustrates the features available with each of the CLS-compatible Speedlights:

FLASH MODE/FEATURE		SB-910 SB-900 SB-800	SB-700	SB-600	SB-400	SB-910 SB-900 SB-800	SB-700	SU-800[1]	SB-910 SB-900 SB-800	SB-700 SB-600	SB-R200
	FLASH UNIT					ADVANCED WIRELESS LIGHTING					
						COMMANDER			REMOTE		
i-TTL	i-TTL balanced fill-flash for digital SLR[2]	✓[3]	✓[4]	✓[3]	✓[4]	✓	✓	✓	✓	✓	✓
AA	Auto aperture [2]	✓[5]	—	—	—	✓[6]	—	✓[6]	✓[6]	—	—
A	Non-TTL auto	✓[5]	—	—	—	✓[6]	—	—	✓[6]	—	—
GN	Distance-priority manual	✓	✓	—	—	—	—	—	—	—	—
M	Manual	✓	✓	✓	✓[7]	✓	✓	✓	✓	✓	✓
RPT	Repeating flash	✓	—	—	—	✓	—	✓	✓	✓	—
AF-assist for multi-area AF [8]		✓	✓	✓	—	✓	✓	✓	—	—	—
Flash Color Information Communication		✓	✓	✓	✓	✓	✓	—	—	—	—
REAR	Rear-curtain sync	✓	✓	✓	✓	✓	✓	✓	✓	✓	✓
◉	Red-eye reduction	✓	✓	✓	✓	✓	✓	—	—	—	—
Power zoom		✓	✓	✓	✓	✓	✓	—	—	—	—

1 Only available when SU-800 is used to control other flash units. The SU-800 itself is not equipped with a flash.
2 CPU lens required.
3 Standard i-TTL flash for digital SLR is used with spot metering or when selected with flash unit.
4 Standard i-TTL flash for digital SLR is used with spot metering.
5 Selected with flash unit.
6 Auto aperture (AA) is used regardless of mode selected with flash unit.
7 Can be selected with camera.

NOTE: When using an external Speedlight with Programmed-Auto (P) exposure mode, the maximum aperture (smallest f/number) is limited according to the ISO sensitivity set on the D3200.

MAXIMUM APERTURE AT ISO					
100	200	400	800	1600	3200
4	5	5.6	7.1	8	10

If the value of the maximum aperture of the lens (lowest f/ number) is lower than the value in the table above, the maximum aperture of the lens will be limited to the value given in the table, for example, a lens will a maximum aperture of f/1.8 has an effective maximum aperture of f/5.6 in P mode with an ISO sensitivity of ISO 400.

The built-in Speedlight of the D3200 has a guide number of 39 feet (12 m) at ISO 100 68°F (20°C) when used in its TTL modes. The maximum normal flash synchronization speed in all exposure modes is 1/200 second. The minimum flash shooting distance is 2 feet (0.6m), below which the camera will not necessarily calculate a correct flash exposure.

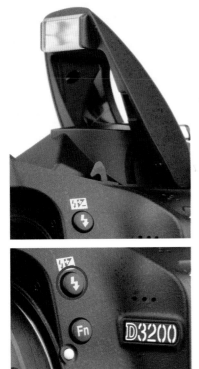

‹ The built-in Speedlight of the D3200 has a guide number (GN) of 39 feet (12m) at ISO 100, a relatively low guide number compared with that of an external Speedlight like the SB-700.

‹ The 𝟦 Flash Mode button for the built-in flash is located on the left side of the camera; it also acts as the flash-release button in P, S, A, and M exposure modes.

The built-in Speedlight is switched on automatically in 🅰🆄🆃🅾, ⊘ , and the Scene modes, while in P, S, A, and M exposure modes it is necessary to press the Flash button that is located on the left side of the viewfinder head. The unit draws its power from the main camera battery. Therefore, extended use of the flash will have a direct impact on battery life. As soon as the flash pops up, it begins to charge. The flash-ready symbol (𝟦) appears in the viewfinder to indicate charging is complete, and the flash is ready to fire. If the flash fires at its maximum output, the same flash-ready symbol will blink for approximately 3 seconds after the exposure has been made, as a warning of potential underexposure. The flash-ready symbol operates in exactly the same way when an external Speedlight is attached and switched on.

Range, Aperture, and ISO Sensitivity: The built-in flash unit's shooting range will vary depending on the values set for the lens aperture and ISO sensitivity:

APERTURE AT ISO							RANGE
100	200	400	800	1600	3200	6400	FEET / METERS
1.4	2	2.8	4	5.6	8	11	3.3 – 27.9 ft. / 1.0 – 8.5 m
2	2.8	4	5.6	8	11	16	2.3 – 19.7 ft. / 0.7 – 6.0 m
2.8	4	5.6	8	11	16	22	2 – 13.8 ft. / 0.6 – 4.2 m
4	5.6	8	11	16	22	32	2 – 9.8 ft. / 0.6 – 3.0 m
5.6	8	11	16	22	32	-	2 – 6.9 ft. / 0.6 – 2.1 m
8	11	16	22	32	-	-	2 – 4.9 ft. / 0.6 – 1.5 m
11	16	22	32	-	-	-	2 – 3.6 ft. / 0.6 – 1.1 m
16	22	32	-	-	-	-	2 – 2.3 ft. / 0.6 – 0.7 m

NOTE: When using the built-in Speedlight with Programmed-Auto (P) exposure mode, the maximum aperture (smallest f/number) is limited according to the ISO sensitivity set on the camera.

^ The position of the built-in Speedlight restricts the lighting effects that can be achieved; however, here it was used as a fill light in conjunction with a second flash unit that provided the main source of illumination.

100	200	400	800	1600	3200
2.8	3.5	4	5	5.6	7.1

If the value of the maximum aperture of the lens (lowest f/number) is lower than the value in the table above, the maximum aperture of the lens will be limited to the value given in the table—for example, a lens with a maximum aperture of f/1.8 has an effective maximum aperture of f/4 in P mode with an ISO sensitivity of ISO 400.

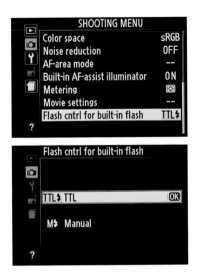

SHOOTING MENU

Color space	sRGB
Noise reduction	OFF
AF-area mode	--
Built-in AF-assist illuminator	ON
Metering	
Movie settings	--
Flash cntrl for built-in flash	TTL⚡

‹ This is the [Flash cntrl for built-in flash] item in the Custom Settings menu.

Flash cntrl for built-in flash

TTL⚡ TTL [OK]

M⚡ Manual

‹ Here are the options available under the [Flash cntrl for built-in flash] item.

Limitations of the Built-In Speedlight: While the D3200's built-in Speedlight is not as powerful as an external Speedlight, it can still provide a useful level of illumination at short ranges, and it is especially useful for fill-flash techniques since it supports flash compensation in the P, S, A, and M exposure modes. However, if you want to use this built-in unit as the main light source, you should be aware of the following:

- The guide number (GN) is limited, thus flash shooting ranges are relatively short.
- The flash head is physically much closer to the central lens axis than that of an external flash, which drastically increases the likelihood of red-eye.
- The close proximity of the built-in Speedlight to the central lens axis often means that the lens obscures the output of the flash, especially if a lens hood is in use. For example, if the camera is held in a horizontal orientation, the obstruction of the light from the flash will cause a shadow to appear on the bottom edge of the picture.
- The angle of coverage achieved by the built-in Speedlight is limited, and only extends to cover the field of view of a lens with a focal length of 18mm. If used with a shorter focal length lens, the flash will not be able to illuminate the periphery of the frame, and these areas will appear underexposed. Even at the widest limit of coverage, it is not uncommon to see a noticeable fall-off of illumination (vignetting) in the corners of the frame.
- The built-in Speedlight draws its power from the camera's battery, so extended use will deplete it quite quickly.

Lens Compatibility with the Built-In Speedlight: The built-in flash can be used with CPU lenses (i.e., all AF and Ai-P types) with focal lengths between 18 – 300 mm, but always remove the lens hood to prevent light from the flash from being obscured. Regardless, the built-in flash has a minimum range of 2 feet (0.6 m), so it cannot be used at the close focus distances. Furthermore, it is not possible to use the built-in Speedlight with the AF-S 14–24mm f/2.8G ED, as light is always obscured, regardless of the focal length in use. The built-in flash may be unable to illuminate the entire frame area evenly when using the following lenses at focus distances shorter than those given in the right-hand column:

LENS	FOCAL LENGTH	MINIMUM DISTANCE
AF-S DX 10 – 24mm f/3.5 – 4.5 G ED	24mm	8.1 ft. / 2.5 m
AF-S DX 12 – 24mm f/4 G ED	24mm	3.25 ft. / 1 m
AF-S DX 16 – 85mm f/4 G ED VR	35mm	3.25 ft. / 1 m
AF-S 17 – 35mm f/2.8 D ED	28mm	3.25 ft. / 1 m
	35mm	No vignetting
AF-S DX 17 – 55mm f/2.8 G ED	28mm	4.9 ft. / 1.5 m
	35mm	3.25 ft. / 1 m
	45–55 mm	No vignetting
AF-S DX 18 – 35mm f/3.5 – 4.5 D	24 mm	3.25 ft. / 1 m
	28-35 mm	No vignetting
AF-S DX 18 – 105mm f/3.5 – 5.6 G	18 mm	9.8 ft. / 3.5 m
	24 mm	3.25 ft. / 1 m
AF-S DX 18 – 135mm f/3.5 – 5.6 G	18 mm	6.5 ft. / 2 m
	24 -135 mm	No vignetting
AF-S DX 18 – 200mm f/3.5 – 5.6 G, VR I & VR II versions	24 mm	3.25 ft. / 1 m
	35 – 200 mm	No vignetting
AF 20 – 35mm f/2.8 D ED	24 mm	8.1 ft. / 2.5 m
	28 mm	3.25 ft. / 1 m
	35mm	No vignetting
AF-S 24mm f/1.4 G ED	24 mm	3.25 ft. / 1 m
AF-S 24 – 70mm f/2.8 G ED	35 mm	4.9 ft. / 1.5 m
	50–70 mm	No vignetting
AF-S 24 – 120mm f/4 G ED VR	24 mm	4.9 ft. / 1.5 m
AF-S 28 – 70mm f/2.8 D ED	35 mm	4.9 ft. / 1.5 m
	50 – 70 mm	No vignetting
AF-S 28 – 300mm f/3.5 – 5.6 G ED	28 mm	4.9 ft. / 1.5 m
	35 mm	3.25 ft. / 1 m

FLASH SYNC MODES

The flash sync mode determines when the built-in or external Speedlight flash unit fires in relation to the opening and closing of the shutter. To select a flash sync mode, press and hold the ⚡ button and rotate the Command dial until the required flash sync mode is displayed in the information display. Alternatively, press the ⚟ button to open the information display and press it again to highlight the cursor; shift the cursor using the Multi Selector button to select the flash sync mode item, and then press the ⊛ button to display the available flash sync options. Use the Multi Selector to highlight the required option and press ⊛ to select it. The availability of a particular flash sync mode will depend on the selected shooting mode, as follows.

With ⚙AUTO ⚞ ⚟ and ❀ shooting modes:

⚡ **Auto:** The built-in flash will pop up automatically if the camera determines that the ambient light level is low or the subject is backlit strongly.

⚡ ◉ **Auto Flash with Red-Eye Reduction:** This operates in the same way as Auto flash, except the red-eye reduction lamp will illuminate briefly before the flash fires. When using the built-in flash, the red-eye reduction lamp lights for approximately one second before the main flash output, while with an external Speedlight a short series of low-intensity light pulses are emitted before the main output. The purpose is to try to induce the pupils of the subject's eyes to constrict, thus reducing the risk of red-eye.

‹ These are the flash sync mode options available in ⚙AUTO mode.

HINT: This mode not only alerts your subject that you are about to take a picture, but it also causes an inordinate delay in the shutter's operation, by which time the critical moment has generally passed and you have missed the shot! Personally, I never bother with this feature. Red-eye can easily be edited out later.

⊛ **Flash Off:** Operation of the flash unit is cancelled regardless of the prevailing light conditions.

With ▣ shooting mode:

⚡ ◉ **AUTO SLOW Auto Flash with Slow Sync and Red-Eye Reduction:** This operates in the same way as Auto flash with slow sync, except the red-eye reduction lamp will illuminate briefly before the flash fires.

⚡ AUTO SLOW **Auto Flash with Slow Sync:** The built-in flash pops up automatically when the camera detects low-level ambient light, but this option offers an extended range of shutter speeds between 1/200 and 1 second to enable the camera to record the ambient light.

⚡ **Flash Off:** Operation of the flash unit is cancelled regardless of the prevailing light conditions.

> These are the flash sync mode options available in ⚡ mode.

With P and A shooting modes:

⚡ **Fill-Flash:** The built-in flash will pop up only if the ⚡ button is pressed. The flash fires as soon as the shutter has opened.

⚡ 👁 **Red-Eye Reduction:** This operates in the same way as Fill-flash, except the red-eye reduction lamp will illuminate briefly before the flash fires.

∧ When shooting with flash in low ambient light, the best way to avoid the red-eye effect is to bounce the light from the flash unit off a nearby wall or ceiling.

⚡ 👁 SLOW Slow-Sync + Red-Eye Reduction: This operates in the same way as Fill-flash, except the red-eye reduction lamp will illuminate briefly before the flash fires. All shutter speeds between 30 seconds and 1/200 second are available, so it is useful for recording low-level ambient light as well as those areas of the scene or subject illuminated by flash.

⚡ SLOW Slow-Sync: This operates in the same way as Fill-flash, except all shutter speeds between 30 seconds and 1/200 second are available, so it is useful for recording low-level ambient light as well as those areas of the scene or subject illuminated by flash.

⚡ REAR Rear-Curtain + Slow Sync: The flash fires immediately before the shutter closes. All shutter speeds between 30 seconds and 1/200 second are available, so it is not only useful for recording low-level ambient light as well as those areas of the scene or subject illuminated by flash but also for creating motion blur trails that appear to follow a moving subject (note that in this mode **SLOW** appears in the Information Display when the setting is completed).

‹ Here are the flash sync mode options available in P and A mode.

With M and S shooting modes:

⚡ Fill-Flash: The built-in flash will pop up only if the ⚡ button is pressed. The flash fires as soon as the shutter has opened.

⚡ 👁 Fill-Flash with Red-Eye Reduction: This operates in the same way as Fill-flash, except the red-eye reduction lamp will illuminate briefly before the flash fires.

⚡ REAR Rear-Sync: The flash fires immediately before the shutter closes. All shutter speeds between 30 seconds and 1/200 second are available, so it is not only useful for recording low-level ambient light as well as those areas of the scene or subject illuminated by flash but also for creating motion blur trails that appear to follow a moving subject.

NOTE: If an external Speedlight is attached to the D3200 the flash will fire in every exposure mode, with the exception of ⊘, even in modes that do not support the use of the built-in Speedlight, such as 🏃.

SHUTTER SPEED RESTRICTIONS WITH FLASH

This table summarizes how the shutter speed value is influenced according to the exposure mode that is selected, with either the built-in flash or an external Speedlight:

EXPOSURE MODE	SHUTTER SPEED
Programmed-Auto (P) Aperture-Priority (A) Auto; Child; Close up	Set automatically by camera (1/200 – 1/60 second) [1]
Portrait	Set automatically by camera (1/200 – 1/30 second) [1]
Night Portrait	Set automatically by camera (1/200 – 1-second)
Shutter-Priority (S)	Value selected by user (1/200 – 30-seconds)
Manual (M)	Value selected by user (1/200 – 30-seconds), $bulb$

1. Shutter speed may be set as slow as 30 seconds in slow sync, slow rear-curtain sync, and slow sync with red-eye reduction modes.

FLASH COMPENSATION

Flash compensation, which is only available in P, S, A, and M exposure modes, is used to modify the level of flash output over a range of -3.0EV to +1.0EV. To set flash output compensation, press and hold the ⚡ and ⊡ buttons and rotate the Command dial until the required level is displayed in the information display. Alternatively, press the ⊞ button to open the information display and press it again to highlight the cursor; shift the cursor using the Multi Selector button to select the flash compensation item, and then press the ⊛ button to display the current flash output level. Use the Multi Selector to select the required value and press ⊛ to select it. To restore normal flash output, set the flash compensation to ± 0.0.

> Flash compensation is accessed via the information display. Here, flash output is set to -1.0EV.

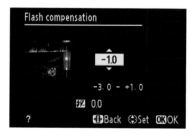

Flash compensation can also be applied directly on compatible external Speedlights (SB-910, SB-900, SB-800, SB-700 and SB-600). If flash compensation is applied on the D3200 and on an external Speedlight at the same time, the effect is cumulative. For example, applying a value of +1.0 EV to both the camera and external Speedlight results in a flash compensation of +2.0 EV.

As discussed earlier in this chapter, the default i-TTL Balanced Fill-Flash mode will automatically set a flash compensation based on scene brightness, contrast, focus distance, and a variety of other factors. The level of automatic adjustment applied to flash output by the D3200 will often cancel out any compensation value entered manually. Since there is no way of telling what the camera is doing, you will never have control of the flash exposure. To regain control, set the flash mode to i-TTL Standard flash by either selecting Spot metering on the camera (this is the only method available with the built-in Speedlight, and optional external SB-700 Speedlight), or set the flash control mode on an external Speedlight accordingly; in the latter case, ensure that only [TTL] is displayed as the flash mode in the Speedlight's control panel, and not [TTL-BL].

FLASH COLOR INFORMATION COMMUNICATION

When Automatic White Balance is selected on the D3200, and you're using the SB-910, SB-900, SB-800, SB-700, SB-600, or SB-400 Speedlight, the external flash unit automatically transmits information to the camera about the color temperature of the light it emits. The camera will then use this information to adjust its final White Balance setting in an attempt to optimize the color temperature of the light from the flash to compensate for the effects of voltage variation from the Speedlight batteries, duration of the flash output, and influence of other non-flash light sources.

AF-ASSIST ILLUMINATOR

The purpose of the AF-Assist lamp built into the SB-910, SB-900, SB-800, SB-700 and SB-600 Speedlights and the SU-800 wireless commander unit is to facilitate autofocus in low-light situations. The AF-Assist lamp on these units is more powerful and covers a much wider area compared with the built-in AF-Assist lamp on the D3200, which has the additional disadvantage of being obstructed by many Nikkor lenses due to its proximity to the lens mount. The effective range of the AF-Assist lamp varies according to the focal length of the lens in use. Furthermore, the use of the AF-Assist lamp introduces restrictions on the AF points that are available for autofocus (see the charts below).

SB-910 and SB-900: Autofocus is only available with the AF points shown in bold.

FOCAL LENGTH OF AF LENS	AF POINTS SUPPORTED BY AF-ASSIST ILLUMINATION
17 – 105mm	
106 – 135mm	

SB-800, SB-600, and SU-800: Autofocus is only available with the AF points shown in bold.

FOCAL LENGTH OF AF LENS	AF POINTS SUPPORTED BY AF-ASSIST ILLUMINATION
24 – 34mm	
35 – 105mm	

SB-700: Autofocus is only available with the AF points shown in bold.

FOCAL LENGTH OF AF LENS	AF POINTS SUPPORTED BY AF-ASSIST ILLUMINATION
25 – 135mm	

HINT: When a compatible external Speedlight with an AF-Assist illuminator is used off the camera (see below), the light emitted by the lamp may not be reflected with sufficient strength to be effective if it strikes the subject at an oblique angle. In this situation, consider using the Nikon SC-29 TTL flash cord, which has a built-in AF-Assist illuminator in its terminal block that attaches to the camera accessory shoe. This places the AF-Assist illuminator immediately above the central axis of the lens to help improve autofocus accuracy.

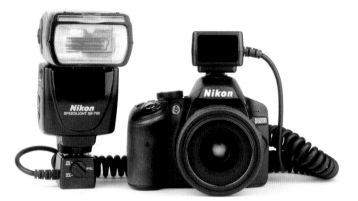

› The SB-700 is connected to the D3200 via the SC-29 TTL flash cable that provides an AF-assist lamp in the accessory shoe of the camera.it is set to the C**H** position.

There are a number of reasons why you may not want to mount your external flash directly on the D3200. The benefits of using a Speedlight off-camera include:

o Increasing the angular separation between the central axis of the lens and the flash head will significantly reduce the risk of the red-eye effect with humans, or eye-shine with other animals.

o In situations when it is not practicable to use bounce flash, moving the flash off-camera will usually improve the quality of the lighting, especially the degree of modeling it provides, compared with the typical flat, frontal lighting produced by a flash mounted on the camera.

o By taking the flash off the camera, and directing the light from the Speedlight accordingly, it is possible to control the position of shadows.

o When using fill-flash, it is often desirable to direct light to a specific part of the scene to help reduce the level of contrast locally.

o An SB-910, SB-900, SB-800 or SB-700 Speedlight connected to the camera via one of Nikon's dedicated TTL cords can be used as the master/commander flash to control multiple Speedlights off-camera using the Advanced Wireless Lighting system (see below).

There are two ways to take your Speedlight off the camera and maintain communication between the two devices: using a cord, or using wireless technology.

Off-Camera Flash Using a TTL Cord: There are several different dedicated Nikon cords for the purpose of connecting the camera and flash: SC-17 (discontinued), SC-28, and SC-29. All three cords are 4.9 feet (1.5 m) long, and up to three, SC-17, or SC-28 cords can be connected together to extend the operating range away from the camera. Whenever you take a Speedlight off the camera and use any TTL flash mode that will incorporate focus distance information in the flash output computations, be careful of where you position the flash. If the Speedlight is moved closer or farther away by a significant amount compared with the camera-to-subject distance, the accuracy of the flash output may be compromised, as the TTL flash control system works on the assumption that the flash is located at the same distance from the subject as the camera. Likewise, when using Manual flash exposure control, remember to calculate the lens aperture based on the flash-to-subject distance, not camera-to-subject distance.

THE ADVANCED WIRELESS LIGHTING SYSTEM

This feature is compatible with the Speedlights that support the CLS (SB-910, SB-900, SB-800, SB-700, SB-600, and SB-R200), together with the SU-800 Wireless Speedlight Commander unit. It allows for one or more remote Speedlight(s) to be operated and controlled wirelessly in up to three autonomous groups, using the P, S, A and M exposure modes available on the D3200. The remote Speedlights can be used in a variety of flash modes: TTL, Auto Aperture (with remote SB-910/SB-900/SB-800 Speedlights only), or Manual. The remote Speedlights are controlled

by pulsed infrared (IR) light (think of it as an optical Morse code), via one of four dedicated communication channels using the SB-910, SB-900, SB-800, or SU-800 as a commander unit.

NOTE: The built-in Speedlight of the D3200 does not support the wireless control of remote flash units, so it is necessary to use either one of the CLS compatible external Speedlights that support this feature (SB-910, SB-900, SB-800, SB-700), or the dedicated SU-800 Wireless Speedlight Commander unit.

> The SB-700 can control up to two groups of compatible Nikon Speedlights, wirelessly, while either being used to contribute light to the flash exposure or just emitting the command signals to the remote.

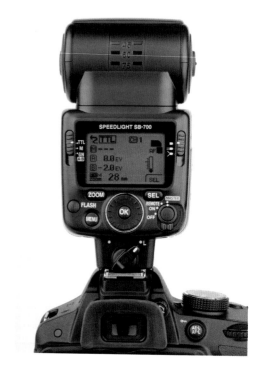

FLASH COMMANDER UNITS – EFFECTIVE RANGES

When the following units are used as the commander unit for wireless control of compatible remote Speedlights, the effective range of operation is as stated:

- SB-910/SB-900/SB-800: When any of these units is used as a commander flash, Nikon states that the maximum effective operating range is 33 feet (10 m) along the central axis of the lens, and 23 feet (7 m) within 30° of the lens' central axis.

- SU-800: This is a dedicated IR transmitter (i.e., unlike the SB-910/SB-900/ SB-800 and built-in Speedlights that emit the control signals as part of a full spectrum emission when used as a master flash, the SU-800 only emits IR light). It is a more powerful transmitter compared with the SB-910, SB-900, and SB-800, so it is capable of controlling remote Speedlights up to a distance of 66 feet (20 m).

- SU-800 / SB-R200: When the SU-800 is used as the commander unit, Nikon states that the maximum effective operating range between it and remote SB-R200 Speedlights is 13 feet (4 m) along the lens' central axis, and 9.8 feet (3 m) within 30° of the lens' central axis.

^ Wireless control of remote, off-camera flash extends the lighting possibilities enormously. Here, two flash units where positioned to camera right and controlled via an SU-800 unit.

Based on my own empirical testing, I have found the quoted maximum operating ranges for the components of the Advanced Wireless Lighting system to be rather conservative, particularly indoors, where reflective surfaces can help to bounce the control signals farther. For example, I have used the SB-910, SB-900 and SB-800 Speedlights as master and remote units at ranges outdoors of 100 feet (30 m) or more, which is three times greater than the suggested maximum range. However, in bright sunlight, which contains a high level of naturally occurring IR light, it is highly likely that the practical limit of the operating range will be reduced, often significantly. In these circumstances, try to shade the IR sensor window on the remote Speedlight units from direct sunlight, as this will improve both effectiveness and reliability of the IR communication system. I have even managed to use remote flash units very successfully without direct line of sight between the master flash / commander unit and the sensor on the remote Speedlight(s), again particularly indoors, by taking an SU-800 unit off-camera using either the SC-28 or SC-29 TTL flash cords, or alternatively bouncing the IR command signals off a reflector. However, every shooting situation is different, so my advice is to set up the lighting system to your requirements, and always take test shots to ensure that it works as intended.

Troubleshooting

There may be occasions when the camera fails to operate or does not operate as expected. Quite often this is due to a specific setting or combination of settings that prevents the D3200 from functioning as intended. The following chart contains a list of common problems that may be encountered, together with an explanation as to their cause and suggested solution(s).

CAMERA DISPLAYS

Viewfinder appears out of focus	O Check and adjust viewfinder eyepiece diopter adjustment control.
Information Display does not appear in LCD monitor	O Shutter release button pressed down halfway; also, confirm [On] is selected for [Auto info display].
Display duration in LCD is too short	O Select longer duration for [Auto off timers].
Viewfinder display is dim and slow to react	O Display is affected by very high/low ambient temperature.

SHOOTING (ALL MODES)

Camera start-up time is protracted	O Delete files/folders from installed memory card(s).
Shutter release disabled	O Memory card is full. O Flash charging. O Focus not acquired. O [Release locked] selected at [Slot empty release lock] and no memory card installed in camera. O Aperture ring of CPU lens not set to highest f/number.
Photograph shows more of scene than shown in the viewfinder	O Viewfinder coverage (horizontal and vertical) is approximately 95%.
Shutter only fires once in Continuous Release modes	O Built-in flash raised; lower it.
Pictures are out of focus	O Camera is in manual focus mode. O Camera is unable to focus automatically; use manual focus. O AF-S or AF-I lens not used.
Focus does not lock when shutter release button is pressed halfway when shooting via the viewfinder	O Use the AE-L/AF-L button to lock focus in AF-C focus mode, or AF-A mode when photographing a moving subject.
Cannot select AF point	O [Auto-area AF] selected for Auto-area mode when shooting via viewfinder. O Turn off monitor by pressing the shutter release button down halfway.
Cannot select AF-area mode	O Manual focus is selected.

SHOOTING (ALL MODES)

Cannot change image size	O Image quality set to [NEF (RAW)] or [NEF (RAW) + JPEG].
Camera is slow to record photographs	O Turn off noise reduction.
Photographs exhibit electronic noise	O Use lower ISO and/or turn on noise reduction. O Shutter speed is longer than 1-second; turn on noise reduction. O Turn [Active D-lighting] off.
Camera does not operate when remote control shutter release button is pressed	O Remote control battery exhausted. O Select a remote control release mode. O Flash is charging. O Time duration selected for [Remote on duration] has elapsed. O High intensity light is interfering with IR signal from remote release.
Warning beep does not operate	O [Off] select for [Beep]. O Quiet release mode selected. O Movie is being recorded. O Manual or AF-C focus mode is selected.
Dark spots/marks or smearing appear in images	O Clean camera lens. O Clean lens filter. O Clean low-pass filter.
Date imprint does not work	O Image quality set to [NEF (RAW)] or [NEF (RAW) + JPEG].
Sound not recorded in movie mode	O [Off] selected for [Microphone].
Flicker or banding occurs during Live View or video recording	O Select appropriate option for [Flicker reduction] to match frequency of AC supply. O Flash or strobe-type light used during Live View/video recording.
Menu item cannot be selected	O Some menu item may not be available depending on camera settings.

SHOOTING (P, S, A, AND M MODES)

Shutter release disabled	O Non-CPU lens attached; use M mode. O S Exposure mode used with bu l b.
Shutter speed range restricted	O Built-in/external flash in use; max sync speed 1/200. O A and P modes used with front curtain flash sync; speeds set between 1/60 – 1/250. O If [On] is selected for [Manual movie settings], the range of shutter speed will be determined by the selected frame rate.
Image exhibits strong color cast	O Match white balance to light source. O Adjust settings for [Picture control].

Camera unable to measure light in **[Preset manual]** white balance	O Reference target (e.g., white/grey card) too dark or too bright.
Reference image cannot be selected for **[Preset manual]** white balance	O Image not recorded by D3200 camera.
Appearance of image varies from picture to picture	O **[Auto]** selected for white balance. O **[Auto]** selected for Picture Control. O Exposure/white balance/ADL bracketing active.
Metering/Exposure settings cannot be altered	O Autoexposure Lock in effect. O Movie is being recorded.

NEF (RAW) image not available in Playback	O **[Image quality]** set to **[NEF (RAW) + JPEG]**.
Not all pictures can be viewed	O **[All]** not selected for **[Playback folder]**.
Photograph recorded in vertical (portrait) orientation displayed in horizontal orientation	O **[Off]** selected for **[Rotate tall]**. O **[Off]** selected for **[Auto image rotation]**. O Camera tilted up/down when image was recorded.
Selected photograph/video clip cannot be deleted	O Remove file protection; display file in Playback and press ⊙ button. O SD memory card is locked.
Selected photograph cannot be edited in Retouch menu	O Image file not recorded by D3200 camera. O Photo has already been edited using the same item in the Retouch menu.
DPOF print order cannot be altered	O Memory card is full. O SD memory card is locked.
Photograph cannot be selected for printing	NEF (RAW) cannot be printed via direct USB connection: O Use **[NEF (RAW) processing]** to create a JPEG copy file. O Transfer file(s) to a computer and print using Nikon or third-party software.
Pictures cannot be displayed on TV / external monitor screen	O Choose correct video mode (NTSC / PAL). O A/V or HDMI cable not connected properly.
Camera does not respond to remote control for HDMI-CEC TV	O Select **[On]** for **[HDMI]** > **[Device control]**. O Adjust settings for the HDMI-CEC device.
Image files not displayed by Nikon Capture NX2	O Update to Nikon Capture NX2 version 2.3.2 or later.

Image Dust Off feature in Nikon Capture NX2 does not work as expected	Image sensor cleaning shifts position of dust on low-pass filter: ○ Dust off reference file recorded before sensor-cleaning operation is performed cannot be used with image file recorded after sensor-cleaning operation is performed. ○ Dust off reference file recorded after sensor-cleaning operation is performed cannot be used with image file recorded before sensor-cleaning operation is performed.
Display of NEF (RAW) file on computer differs from display of same file on camera	○ Third-party software does not show effects of Picture Controls, Active D-Lighting, or Vignette control according to data settings recorded by the camera; use Nikon software.
Image files cannot be transferred from camera to computer	○ Computer operating system not compatible with camera or Nikon Transfer; copy data via a separate card reader.

Date/time data recorded by camera is not correct	○ Adjust settings for [Time zone and date].
Menu item not available (shown in grey)	○ Certain menu options are not available depending on current camera settings or when no memory card is installed.
Camera ceases to function properly	○ Switch off, remove battery and replace it, switch on. If using the AC adapter, disconnect, reconnect, and switch on.

FE E (blinks)	○ Lens aperture not set to minimum value.
● (blinks)	○ Camera unable to focus using autofocus.
Err (blinks)	○ Non-specific camera malfunction.
bulb (blinks)	○ bulb selected in S exposure mode.

Shutter speed (in P and A), and/or aperture (in P and S) blink, plus ▣ blinks	○ Limits of the exposure metering system have been exceeded.
4 blinks for 3-seconds after flash fires	○ Picture may be underexposed.

For	○ Memory card not formatted for camera.
(-E-)	○ Camera cannot detect memory card.
Err (blinks)	○ Memory card cannot be accessed.

MEMORY CARD WARNINGS

FuL *(blinks)* O Insufficient memory to record further images.

Cd *(blinks)* O SD memory card is locked.

Cd / Err *(blinks)* O Memory card cannot be used.

BATTERY WARNINGS

O Battery power is low – recharge battery.

/ Err *(blinks)* O Camera initialization problem; turn off and on again.

/ ☐ *(blinks)* O Battery exhausted / shutter release disabled.

Index

Magic Lantern Genie Guides™

Nikon D3200
Quick Reference Card

Camera Operation Shortcuts

(Assumes Information Display is currently not showing in LCD monitor)

Set Sensitivity (ISO):
Press ⊞ two times, highlight ISO sensitivity mode in information display and press ⊛, highlight desired ISO value; then press ⊛.

Set Metering Mode:
Press ⊞ two times, highlight Metering mode in information display and press ⊛, highlight desired option: ▣ = Matrix, ⊙ = Center, ⊡ = Spot; then press ⊛.

Set Release Mode:
Press ▯ button, highlight desired option and press ⊛: ⊡ = Single, ▢ = Continuous, ◷ = Self-timer, ♢ 2s = Delayed-remote, ▮ = Quick-response remote, ▢ = Quiet.

Set White Balance (WB):
Press ⊞ two times, highlight White balance mode in information display and press ⊛, highlight desired option: AUTO = Automatic, ☀ = Incandescent, ▥ = Fluorescent, ☀ = Direct sunlight, ϟ = Flash, ☁ = Cloudy, ☖ = Shade, PRE = Preset; then press ⊛. Set WB fine-tuning value in Shooting menu.

Set Autofocus Mode:
Press ⊞ two times, highlight Focus mode in information display and press ⊛ highlight required option: AF-A (Auto-servo), AF-S (Single-servo), AF-C (Continuous-servo), or MF (Manual focus); then press ⊛.

Set Autofocus Area Mode:
Press ⊞ two times, highlight AF-area mode in information display and press M, highlight desired option: [□] = Single-point, [⊙] = Dynamic-area, [3D] = 3D-tracking (11 points), ▦ = Auto-area; then press ⊛. To enable manual selection of focus area, select either Dynamic-area or Single-area for AF-area mode.

Set Image Quality:
Press ⊞ two times, highlight Image quality mode in information display and press M, highlight desired option: RAW+F, RAW, FINE, NORM, BASIC; then press ⊛.

Set Image Size:
Press ⊞, press ⊞ again: use ⊕ to highlight Image size in information display, press ⊛, highlight required option: L (large), M (medium), or S (small); then press ⊛.

Live View:
Activate by pressing the ▣ button.

Select Focus mode: Press ⊞ two times, highlight Focus mode in information display and press ⊛, highlight desired option: AF-S, AF-F, MF; then press ⊛. Press ⊞ to return to LV.

Select AF-area mode: Press ⊞ two times, highlight AF-area mode in information display and press ⊛, highlight desired option: ▦ = Face priority, ☷ = Wide area, ▦ = Normal area, ⊞ = Subject tracking; then press ⊛. Press ⊞ to return to LV.

Select Focus point: In Wide and Normal-area AF, press ⊛ to center AF point or use Multi Selector to position it. In Subject-tracking AF, position AF point over subject and press ⊛ to start AF tracking. Press ⊛ again to stop tracking.

Record movie: Press ▣ to activate. Select AF and AF-area modes, focus, and then press the Movie-Record (red) button to start recording; press again to stop recording.

Restore Default Settings:
Use **[Reset Shooting menu]** item in Shooting menu, and **[Reset Setup Options]** in Setup menu.

Using Flash

Set Flash Mode:
Press ⊞ two times, highlight Flash mode in information display and press ⊛, highlight desired option and then press ⊛:

In 🖼, 👤, 🌷, and 🍽 modes: ϟ AUTO = Auto, ϟ ⊛ AUTO = Auto + Red-eye reduction, ⊛ = Flash off.

In 🗻 mode: ϟ ⊛ ⊠ = Auto + slow sync + red-eye reduction, ϟ ⊠ = Auto + slow sync, ⊛ = Flash off.

In P or A modes: ϟ = Fill flash, ϟ ⊛ = Redeye Reduction, ϟ ⊛ ʙʟʙ = Slow sync + Red-eye reduction, ϟSLOW = Slow sync, ϟREAR = Rear-curtain slow sync.

In S or M modes: $\frac{1}{2}$ = Fill flash, $\frac{1}{2}\odot$ = Redeye reduction,
$\frac{1}{2}$REAR = Rear-curtain sync.

Flash Sync Speeds:

🎑, 🏵, 🌄, P, or A = 1/200 - 1/60s; 🏔 = 1/200 - 1s;
𝄪 = 1/200 - 1/30s; S = 1/200 - 30s; ⊛ = 1/200 -
30s; ʙᴜ ⅃ ʙ: All modes = 1/200-30s with **SLOW**,
⊛**SLOW**, ⊛🕮, or $\frac{1}{2}$**REAR** flash sync.

Built-in Flash Illumination Range:

@ISO100	@ISO800	Range
f/1.4	f/4	3'3"-27'11"/1.0 - 8.5m
f/2.8	f/8	2' - 13'9"/0.6 - 4.2m
f/5.6	f/16	2' - 6'11"/0.6 - 2.1m
f/11	f/32	2' - 3'7"/0.6 - 1.1m

Set Flash Compensation:
Press 📷 two times, highlight Flash compensation
mode in information display and press ⊛. Use ▲ or
▼ to set the required value between +1 to –3EV, in
steps of 0.3EV, then press ⊛. Reset value to ±0.0 to
cancel Flash compensation.

Camera Menus

▶ **Playback Menu:**
Delete, Playback folder, Playback display options, Image
review, Rotate tall, Slide show, DPOF Print order.

📷 **Shooting Menu:**
Reset, Set Picture Control, Image quality, Image size,
White balance, ISO sensitivity, Active D-Lighting,
Auto distortion control, Color space, Noise reduction,
AF-area mode, Built-in AF-assist, Metering, Movie set-
tings, Flash control for built-in flash.

Υ **Setup Menu:**
Reset setup options, Format memory card, Monitor
brightness, Info display format, Auto info display,
Clean image sensor, Lock mirror up for cleaning, Video
mode, HDMI, Flicker reduction, Time zone and date,
Language, Image comment, Auto image rotation,
Image dust off ref photo, Auto off timers, Self-timer,
Remote on duration, Beep, Rangefinder, File number
sequence, Buttons, Slot empty release lock, Print date,
Storage folder, GPS, Eye-fi upload, Firmware version.

🖌 **Retouch Menu:**
D-Lighting, Red-eye reduction, Trim, Monochrome,
Filter effects, Color balance, Image overlay, NEF
(RAW) Processing, Resize, Quick retouch, Straighten,
Distortion control, Fisheye, Color outline, Color sketch,
Perspective control, Miniature effect, Selective color,
Edit movie, Side-by-side comparison.

📑 **Recent Settings:**
Displays the 20 most recently used items.